THE PENNINES
Trains in the Landscape
DAVID HAYES

T0294205

AMBERLEY

ABOUT THE AUTHOR

Born in Nottingham in the mid-1950s, and living within a few hundred yards of my local station, it was inevitable that railways would become a passion from an early age. After the usual rite of passage collecting numbers, my interest moved towards photography and capturing what was proving to be a fast-changing railway scene in the 1970s. By the early 1980s, however, my interest waned, and I only returned to the hobby when I came back to the UK after spending several years working overseas. Imminent retirement together with advances in digital photography, and especially the sophisticated processing software now available, all proved key incentives to getting started again.

Rather like I did in the 1970s, I worked through a few cameras (digital in this case) until I found the combination that suited me best. Since 2014 I've been using a Canon EOS 5D Mark III together with 16-35, 24-105, and 100-400 zoom lenses. It hardly makes for a light kit bag when trudging up and down the hills, but for me the image quality more than makes up for any physical discomfort – at least for the time being! All the shots in this book have been taken with this equipment.

First published 2022

Amberley Publishing
The Hill, Stroud
Gloucestershire, GL5 4EP

www.amberley-books.com

Copyright © David Hayes, 2022

The right of David Hayes to be identified as the Authors of this work has been asserted in accordance with the Copyrights, Designs and Patents Act 1988.

ISBN 978 1 3981 0249 1 (print)
ISBN 978 1 3981 0250 7 (ebook)

British Library Cataloguing in Publication Data.
A catalogue record for this book is available from the British Library.

Origination by Amberley Publishing.
Printed in the UK.

INTRODUCTION

The Pennine hills of northern England play host to some of the finest landscapes in the land while also offering up some of the most diverse. It is perhaps no surprise that they have long been a magnet to railway photographers who are keen to challenge themselves in these environments and try capture their character and, sometimes, the more elusive 'bigger scene'.

In this book you will find images predominantly from the more southern section of the Pennine chain – around the attractive limestone dales and industrial quarries of Derbyshire, and the gritty towns and villages of West Yorkshire where stone-built dwellings adorn the hillsides and road, railway, and canal all compete for space along the valley floor. The more northerly and windswept moorlands of the Settle & Carlisle route is not ignored though, and the West Coast Mainline, together with a few other areas, also feature.

The images have all been taken over the last few years with a digital camera and, in many cases, I've tried to compose the shot so that the train becomes part of the landscape rather than dominates it – especially where I think the view is the star of the show!

I hope you enjoy this journey into some of my favourite areas.

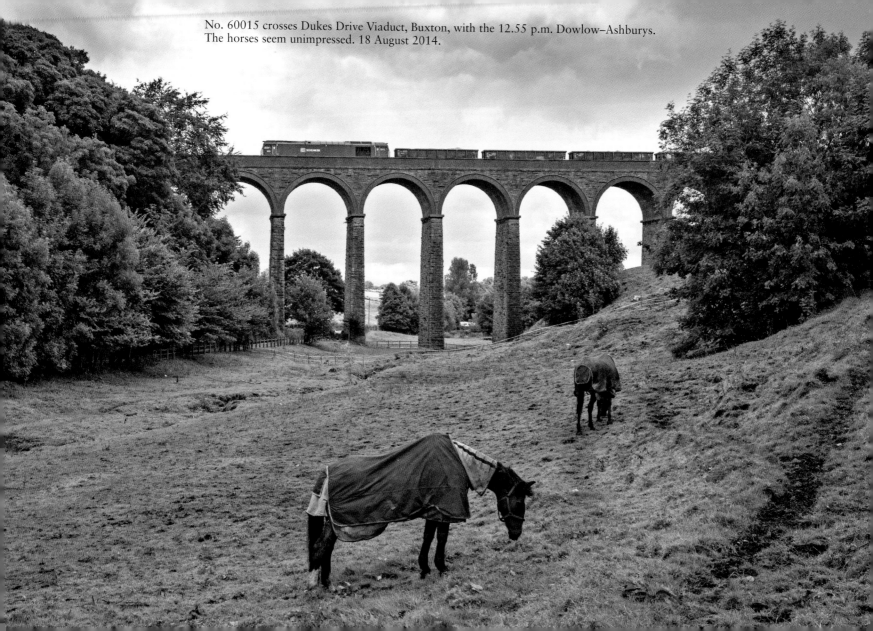

No. 60015 crosses Dukes Drive Viaduct, Buxton, with the 12.55 p.m. Dowlow–Ashburys. The horses seem unimpressed. 18 August 2014.

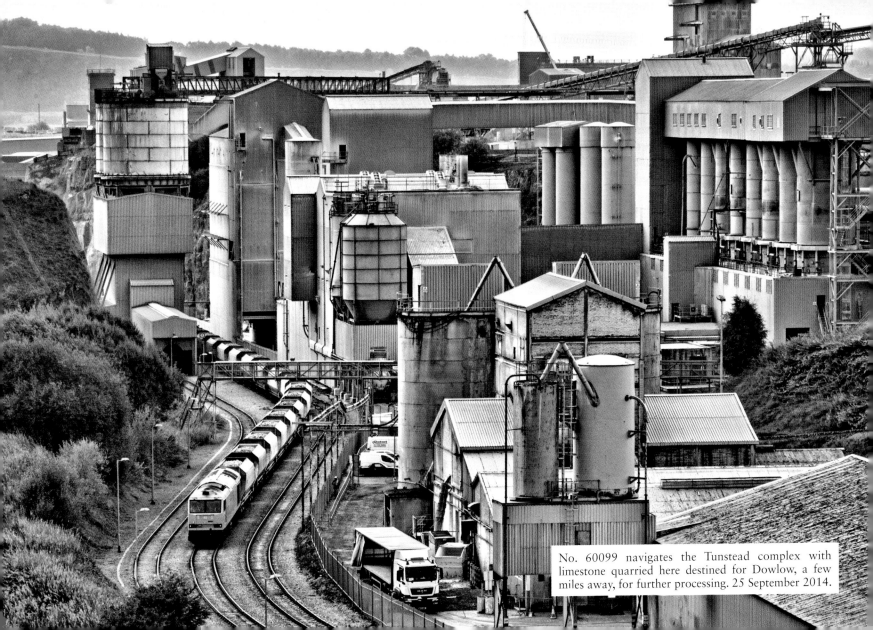

No. 60099 navigates the Tunstead complex with limestone quarried here destined for Dowlow, a few miles away, for further processing. 25 September 2014.

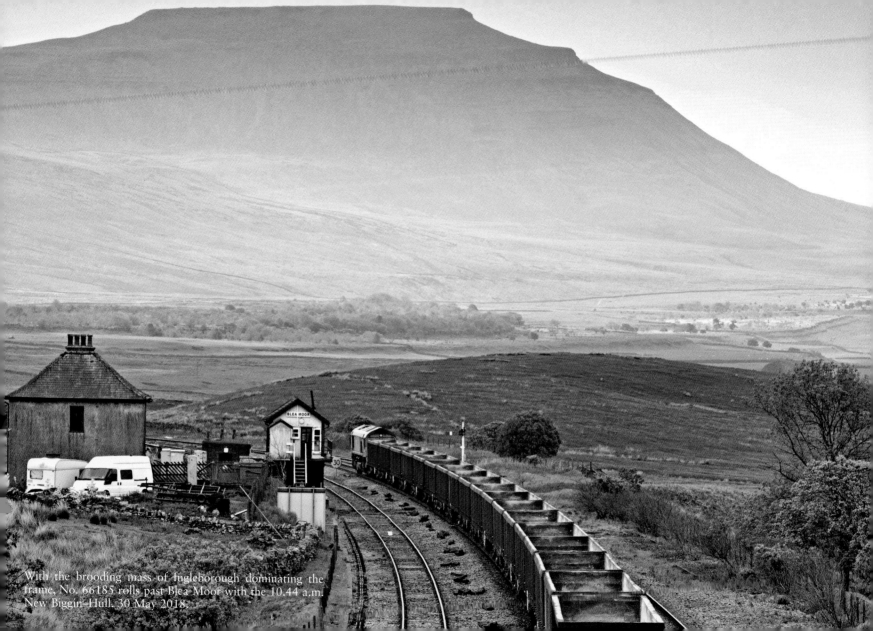

With the brooding mass of Ingleborough dominating the frame, No. 66185 rolls past Blea Moor with the 10.44 a.m. New Biggin–Hull. 30 May 2018.

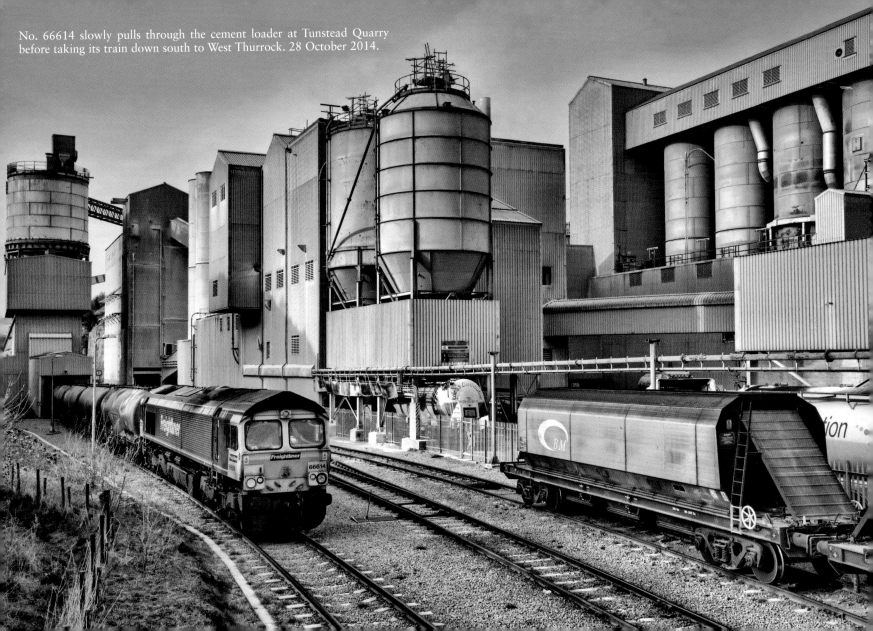

No. 66614 slowly pulls through the cement loader at Tunstead Quarry before taking its train down south to West Thurrock. 28 October 2014.

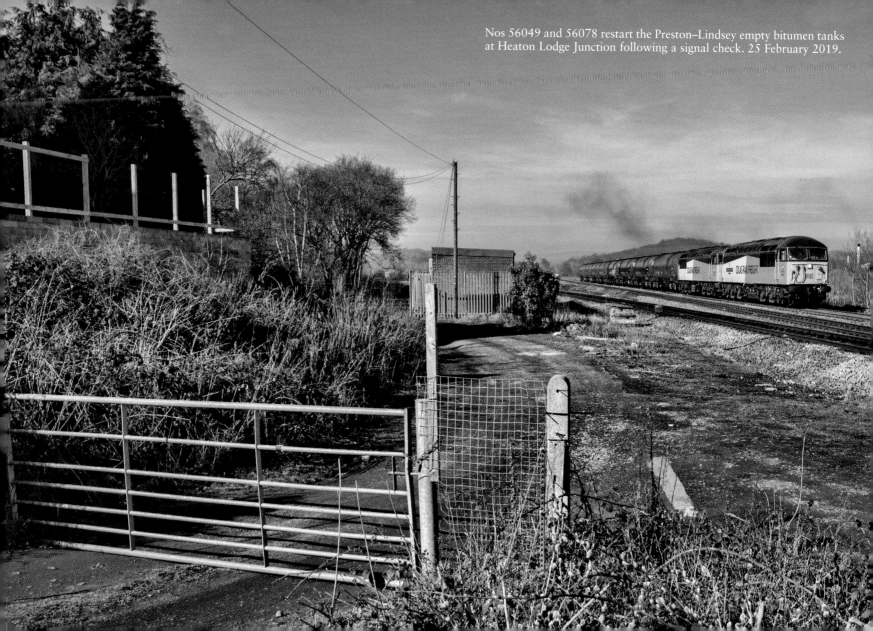

Nos 56049 and 56078 restart the Preston–Lindsey empty bitumen tanks at Heaton Lodge Junction following a signal check. 25 February 2019.

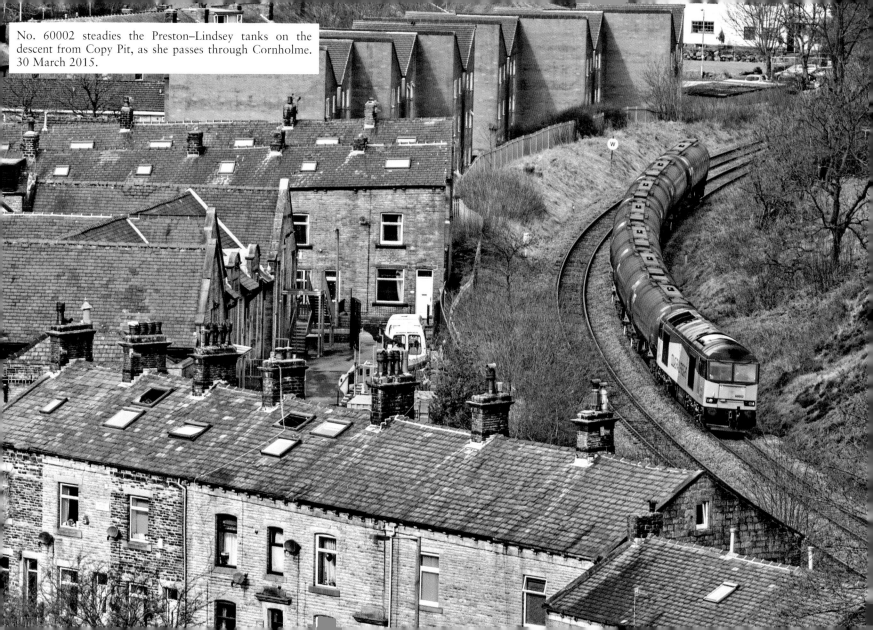

No. 60002 steadies the Preston–Lindsey tanks on the descent from Copy Pit, as she passes through Cornholme. 30 March 2015.

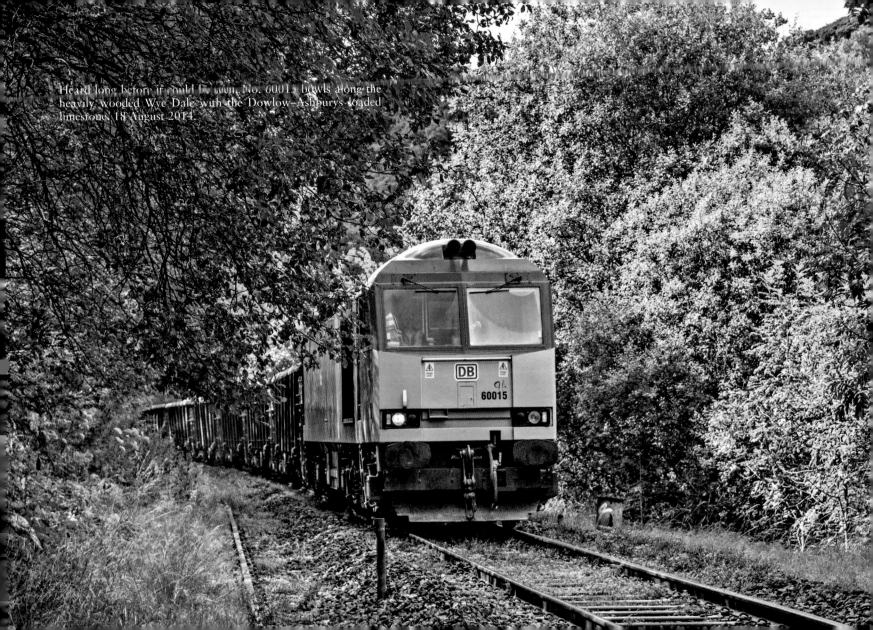

Heard long before it could be seen, No. 60015 bowls along the heavily wooded Wye Dale with the Dowlow–Ashburys loaded limestone, 18 August 2014.

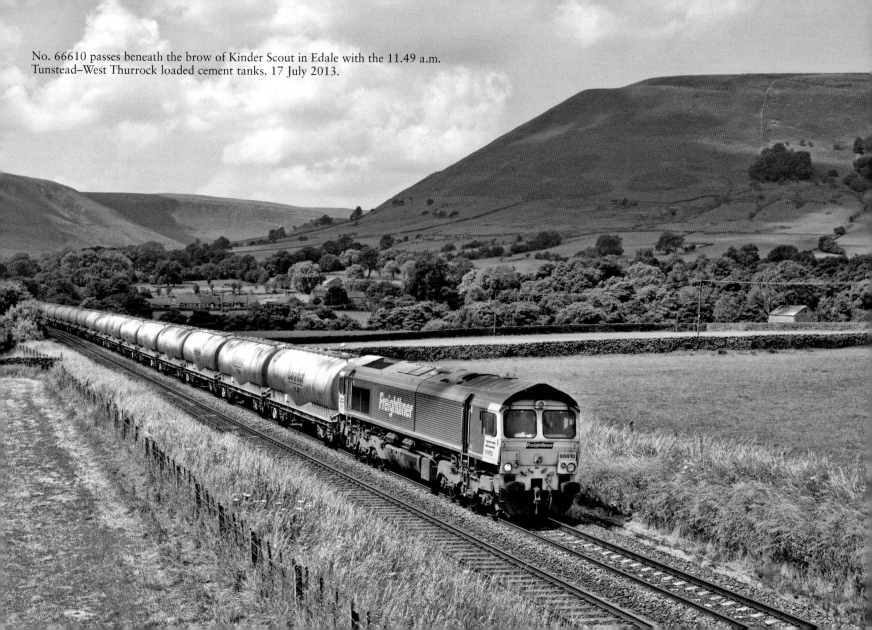

No. 66610 passes beneath the brow of Kinder Scout in Edale with the 11.49 a.m. Tunstead–West Thurrock loaded cement tanks. 17 July 2013.

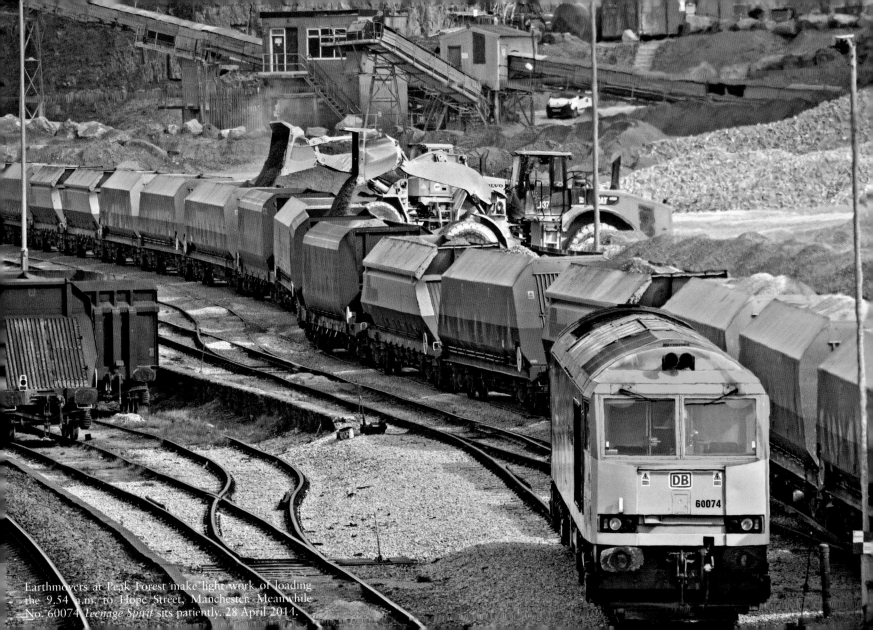

Earthmovers at Peak Forest make light work of loading the 9.54 a.m. to Hope Street, Manchester. Meanwhile No. 60074 *Teenage Spirit* sits patiently. 28 April 2014.

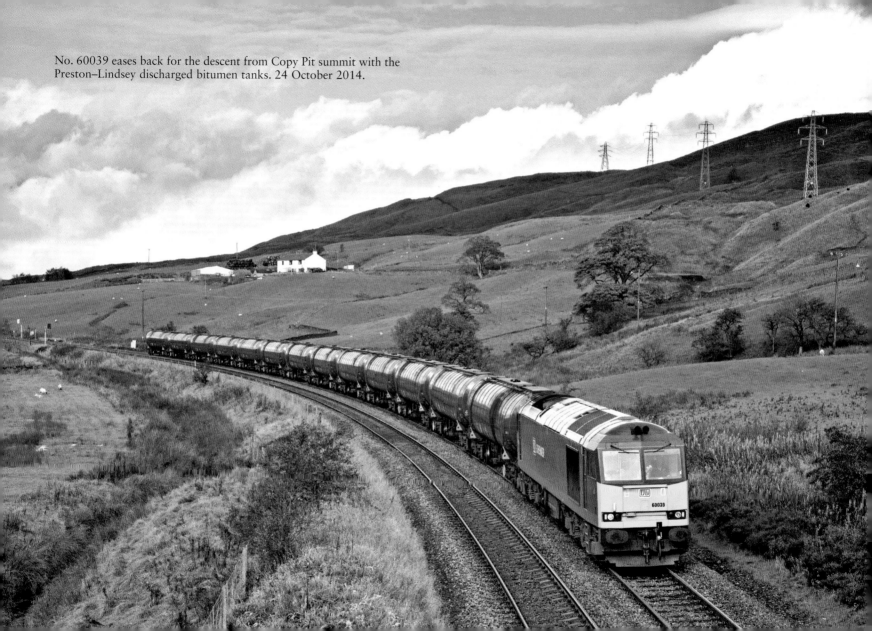

No. 60039 eases back for the descent from Copy Pit summit with the Preston–Lindsey discharged bitumen tanks. 24 October 2014.

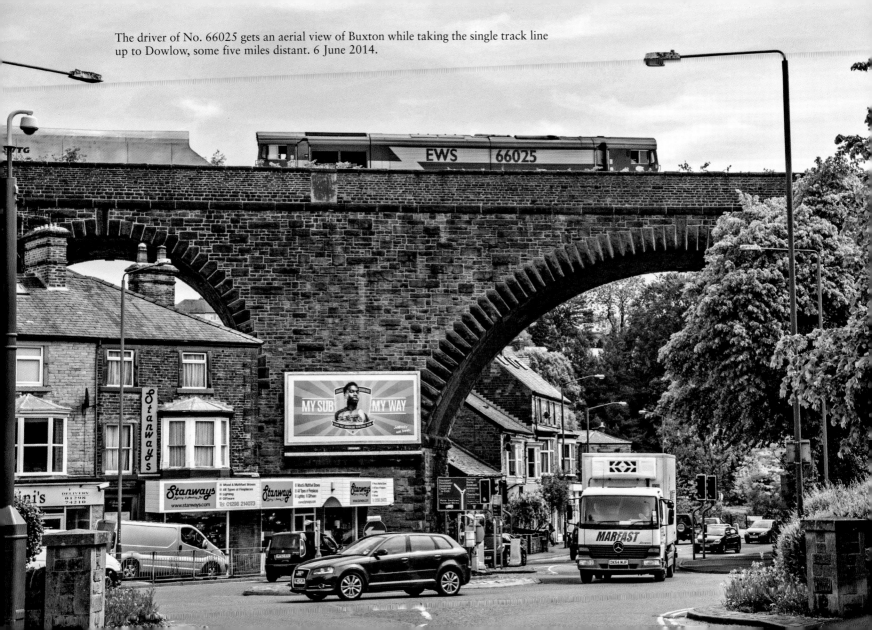
The driver of No. 66025 gets an aerial view of Buxton while taking the single track line up to Dowlow, some five miles distant. 6 June 2014.

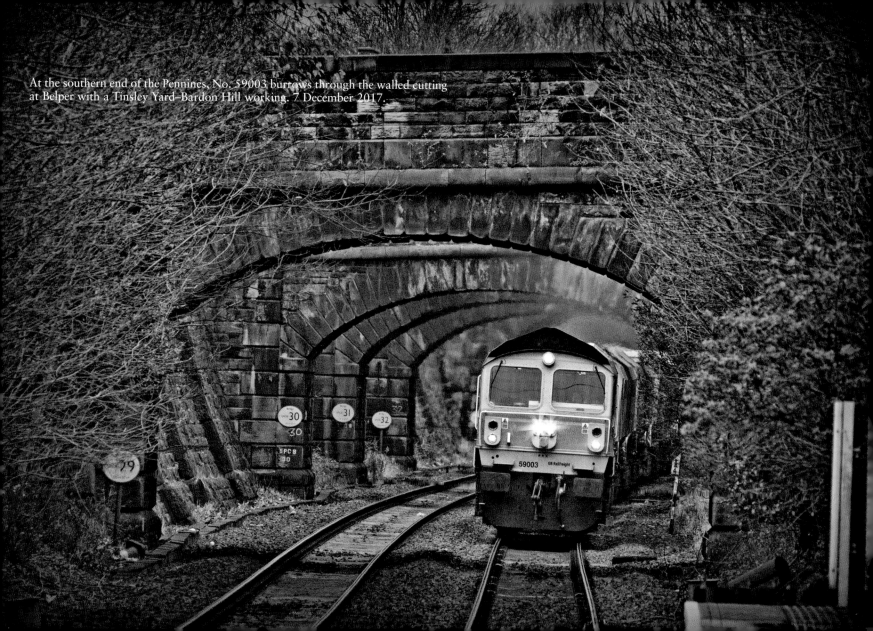

At the southern end of the Pennines, No. 59003 burrows through the walled cutting at Belper with a Tinsley Yard–Bardon Hill working. 7 December 2017.

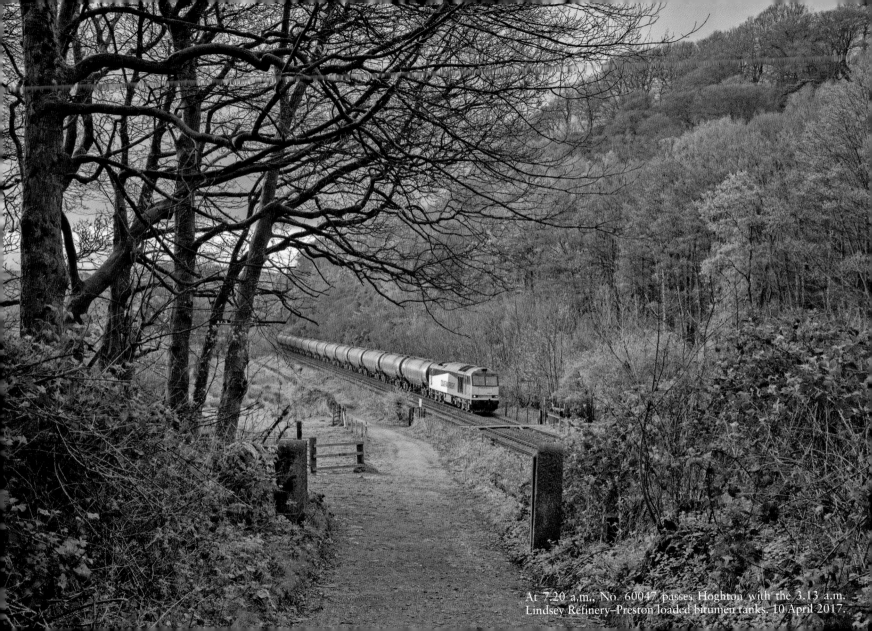

At 7.20 a.m., No. 60047 passes Hoghton with the 3.13 a.m. Lindsey Refinery–Preston loaded bitumen tanks. 10 April 2017.

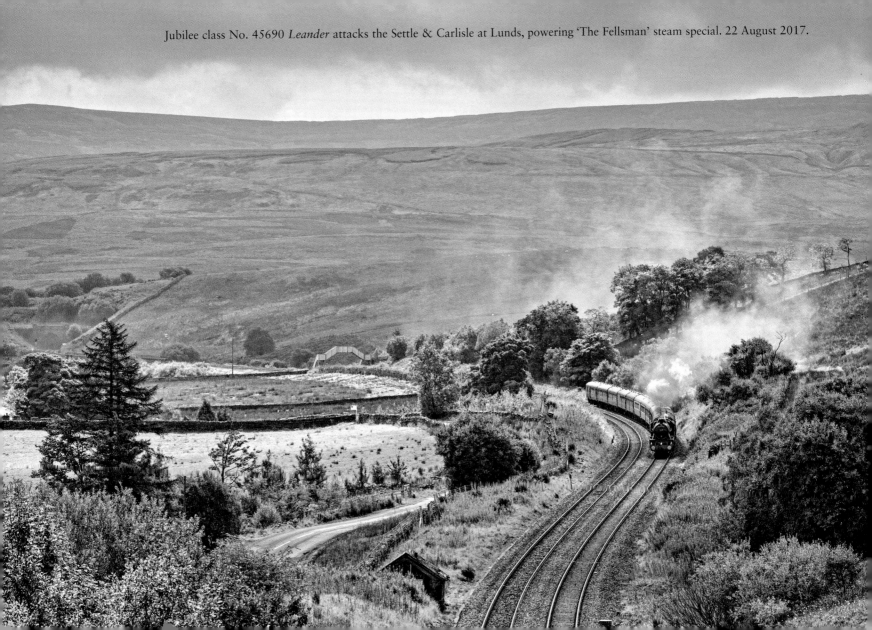

Jubilee class No. 45690 *Leander* attacks the Settle & Carlisle at Lunds, powering 'The Fellsman' steam special. 22 August 2017.

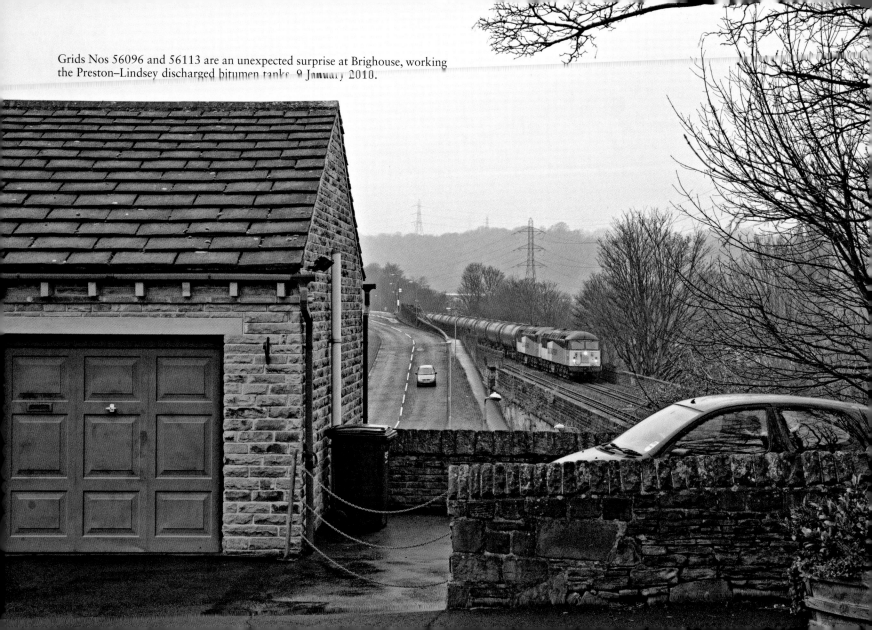

Grids Nos 56096 and 56113 are an unexpected surprise at Brighouse, working the Preston–Lindsey discharged bitumen tanks, 9 January 2010.

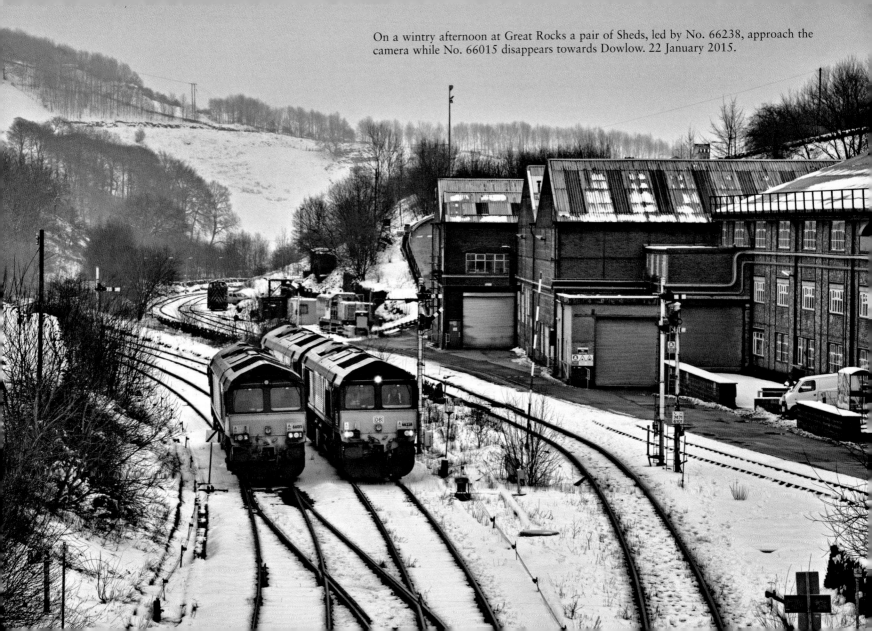

On a wintry afternoon at Great Rocks a pair of Sheds, led by No. 66238, approach the camera while No. 66015 disappears towards Dowlow. 22 January 2015.

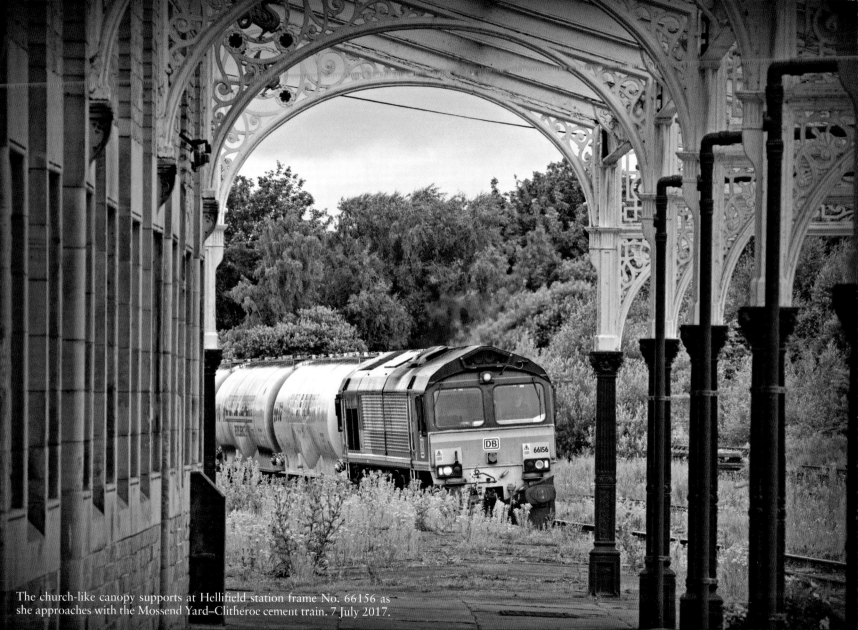

The church-like canopy supports at Hellifield station frame No. 66156 as she approaches with the Mossend Yard–Clitheroe cement train. 7 July 2017.

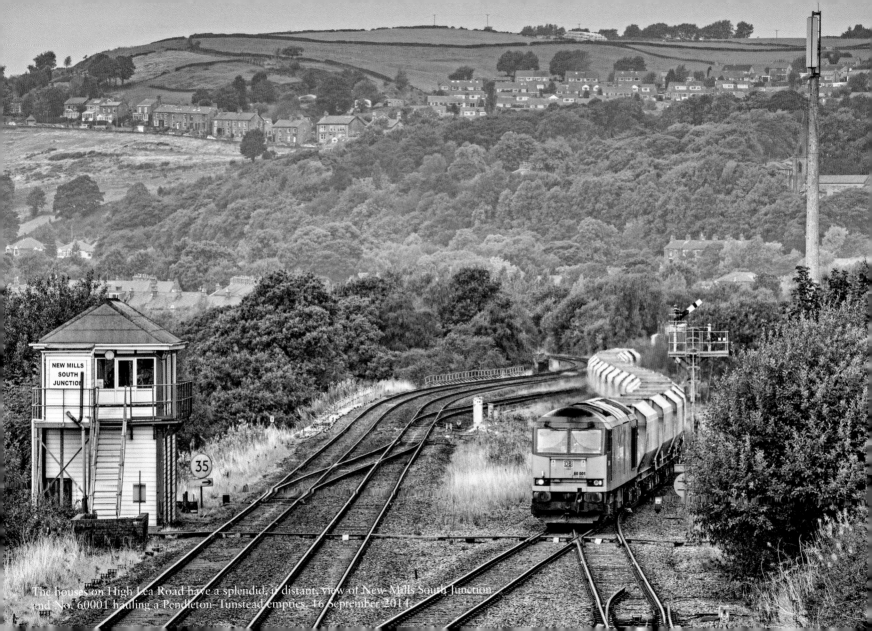

The houses on High Lea Road have a splendid, if distant, view of New Mills South Junction and No. 60001 hauling a Pendleton–Tunstead empties, 16 September 2014.

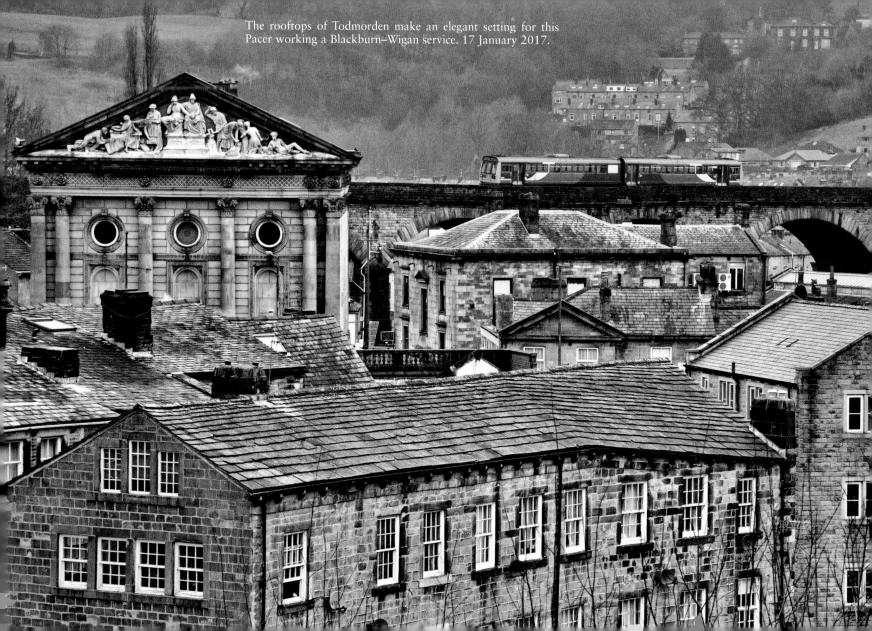

The rooftops of Todmorden make an elegant setting for this Pacer working a Blackburn–Wigan service. 17 January 2017.

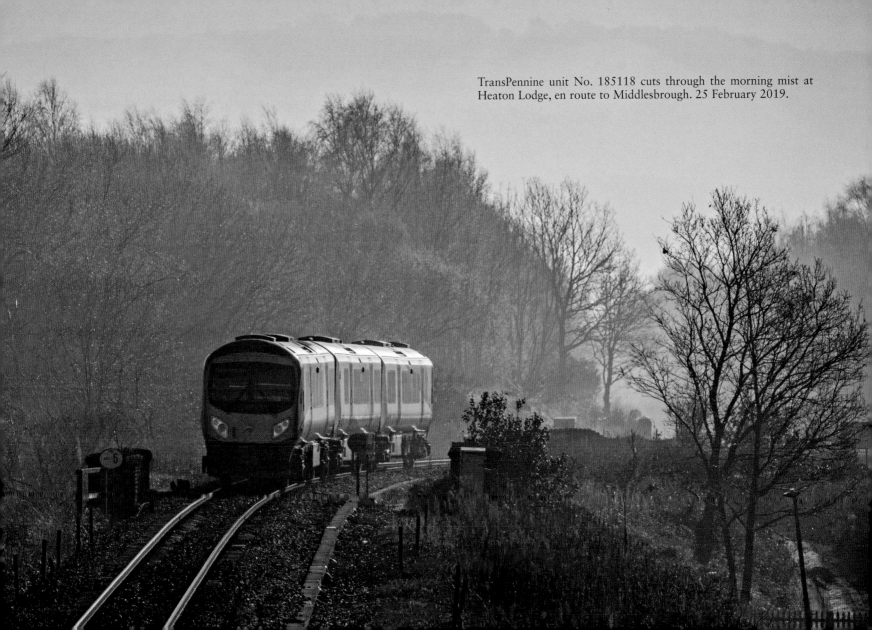
TransPennine unit No. 185118 cuts through the morning mist at Heaton Lodge, en route to Middlesbrough. 25 February 2019.

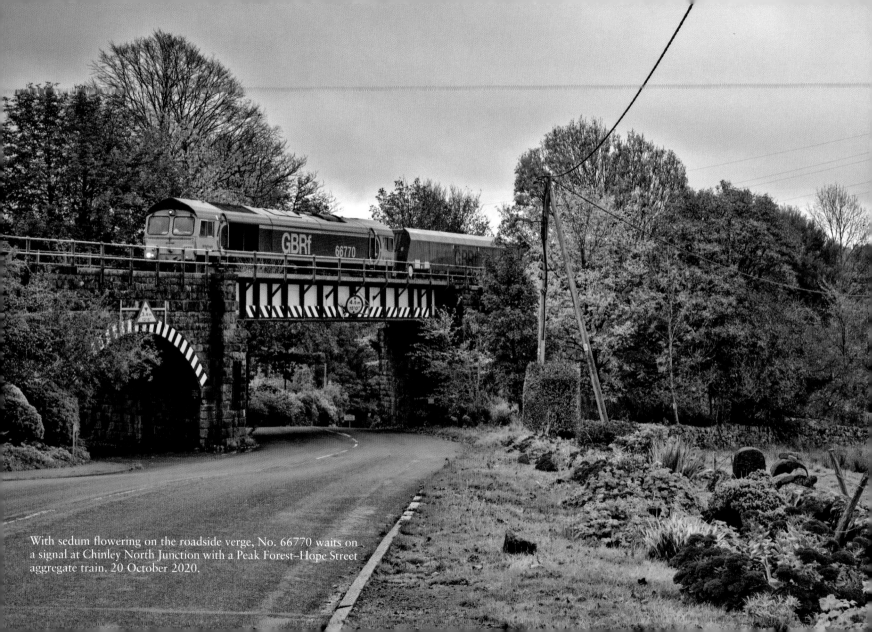

With sedum flowering on the roadside verge, No. 66770 waits on a signal at Chinley North Junction with a Peak Forest–Hope Street aggregate train. 20 October 2020.

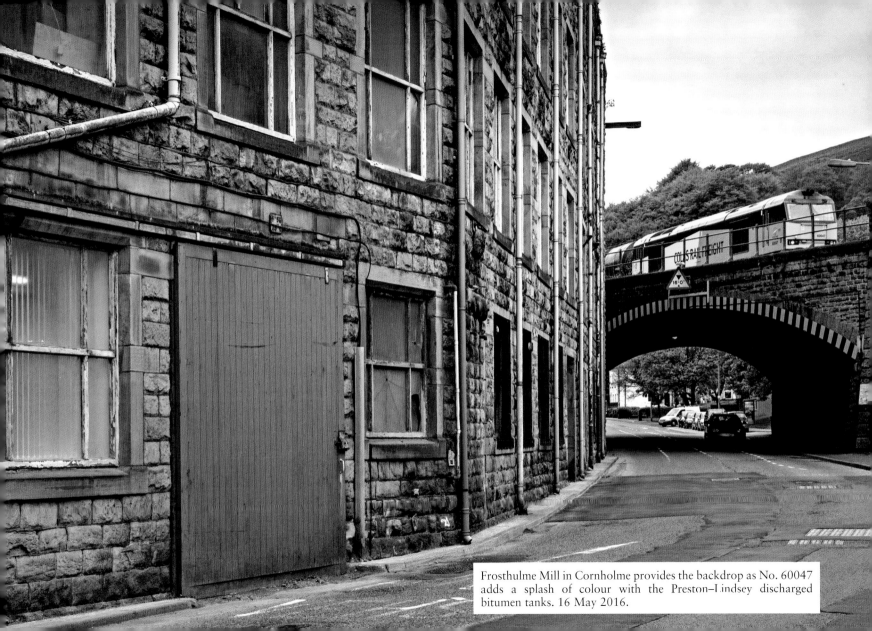

Frosthulme Mill in Cornholme provides the backdrop as No. 60047 adds a splash of colour with the Preston–Lindsey discharged bitumen tanks. 16 May 2016.

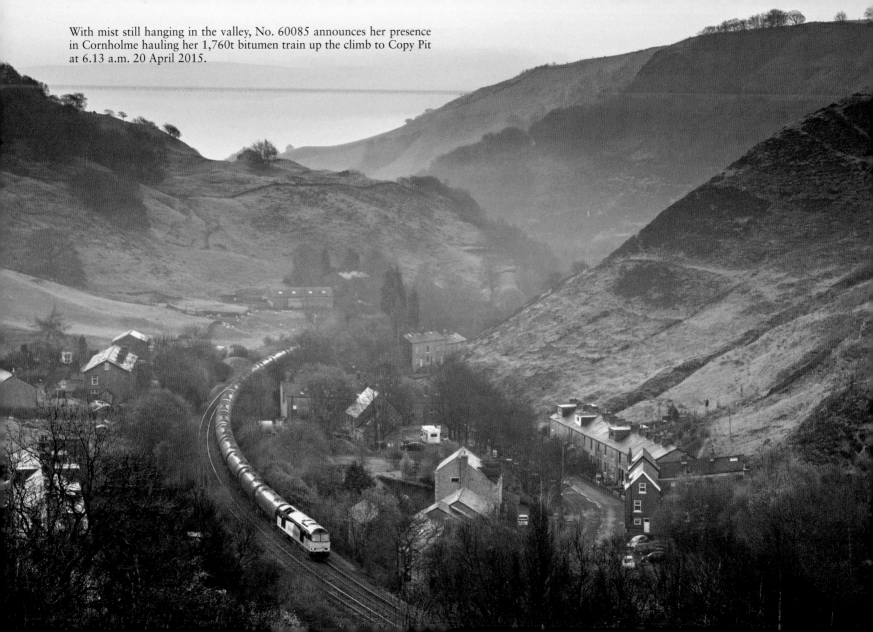

With mist still hanging in the valley, No. 60085 announces her presence in Cornholme hauling her 1,760t bitumen train up the climb to Copy Pit at 6.13 a.m. 20 April 2015.

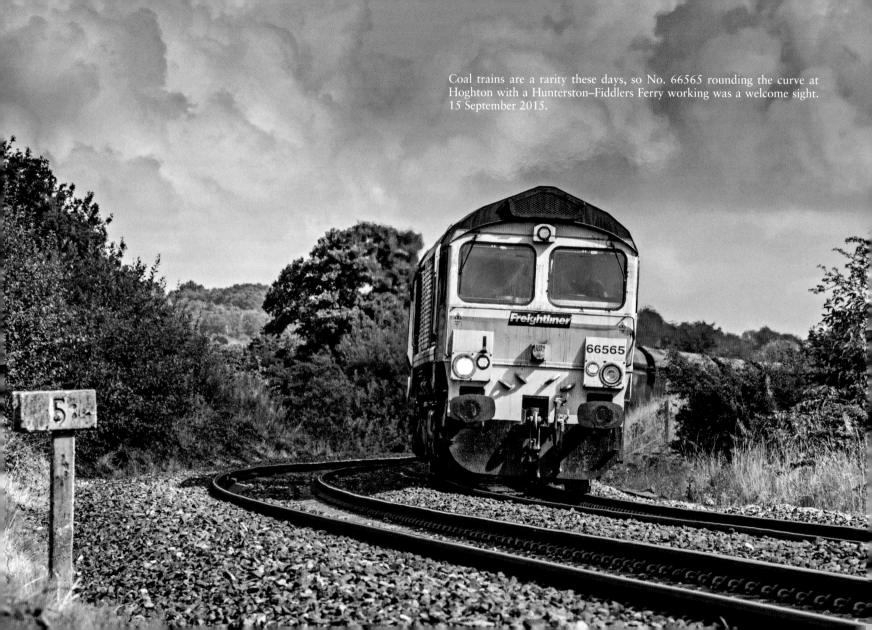

Coal trains are a rarity these days, so No. 66565 rounding the curve at Hoghton with a Hunterston–Fiddlers Ferry working was a welcome sight. 15 September 2015.

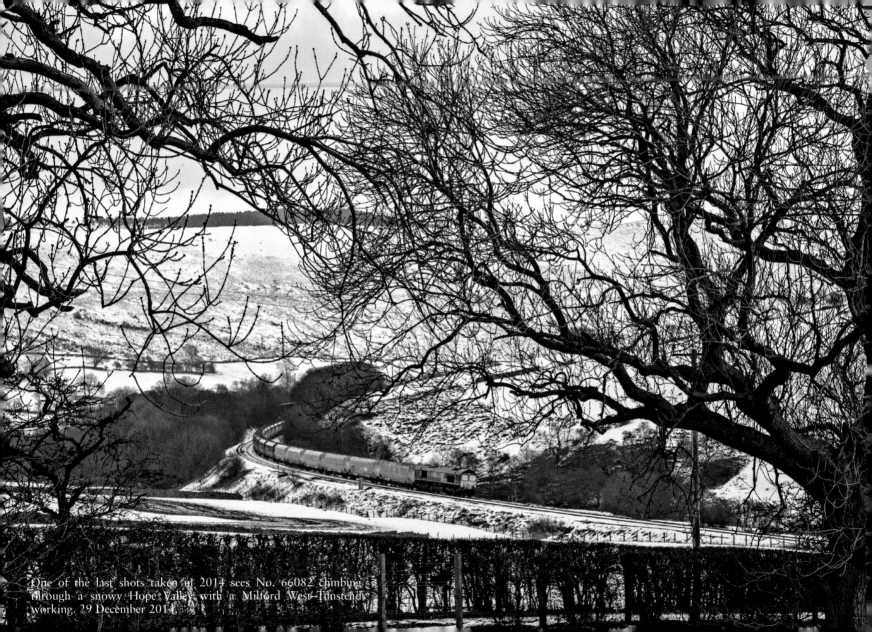

One of the last shots taken in 2014 sees No. 66082 climbing through a snowy Hope Valley with a Milford West–Tunstead working. 29 December 2014.

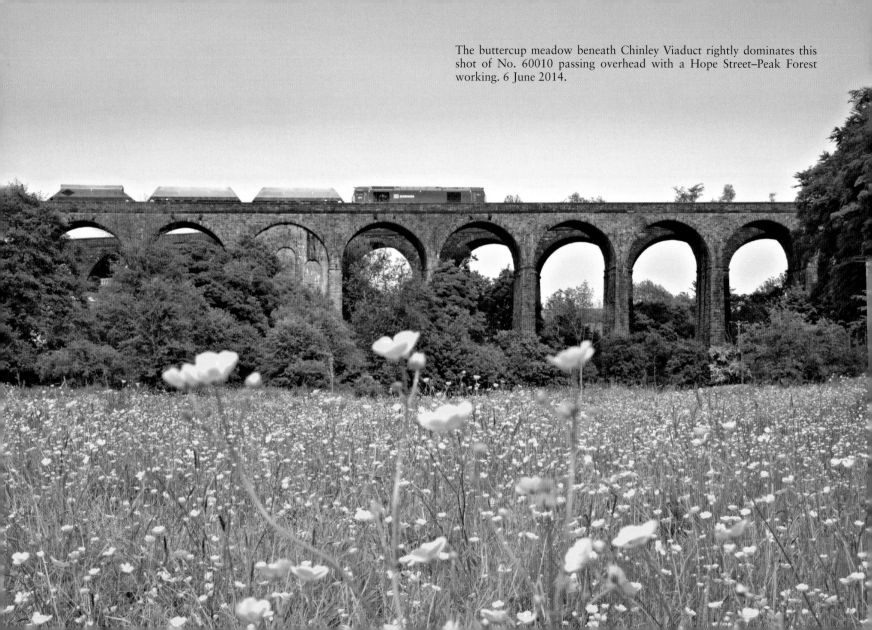

The buttercup meadow beneath Chinley Viaduct rightly dominates this shot of No. 60010 passing overhead with a Hope Street–Peak Forest working. 6 June 2014.

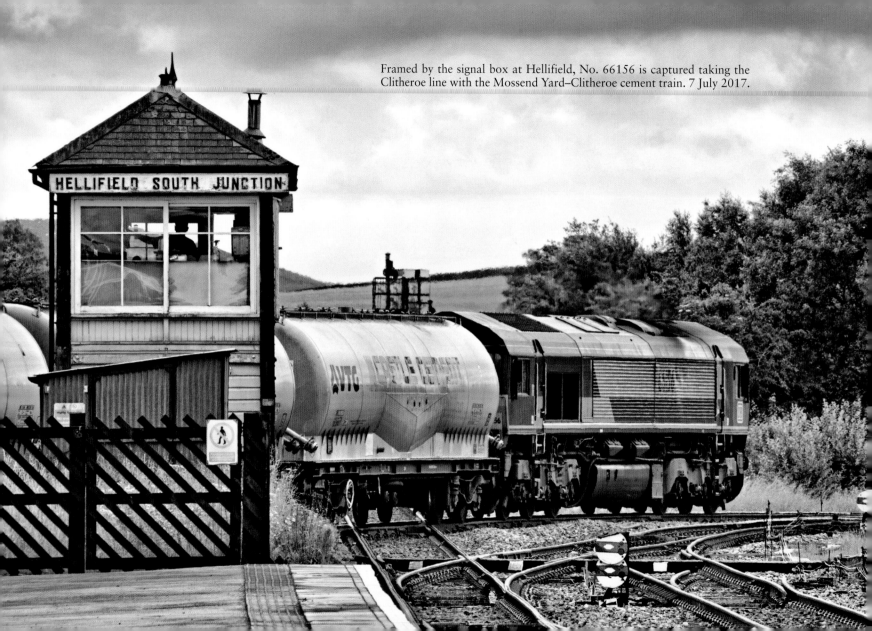

Framed by the signal box at Hellifield, No. 66156 is captured taking the Clitheroe line with the Mossend Yard–Clitheroe cement train. 7 July 2017.

HELLIFIELD SOUTH JUNCTION

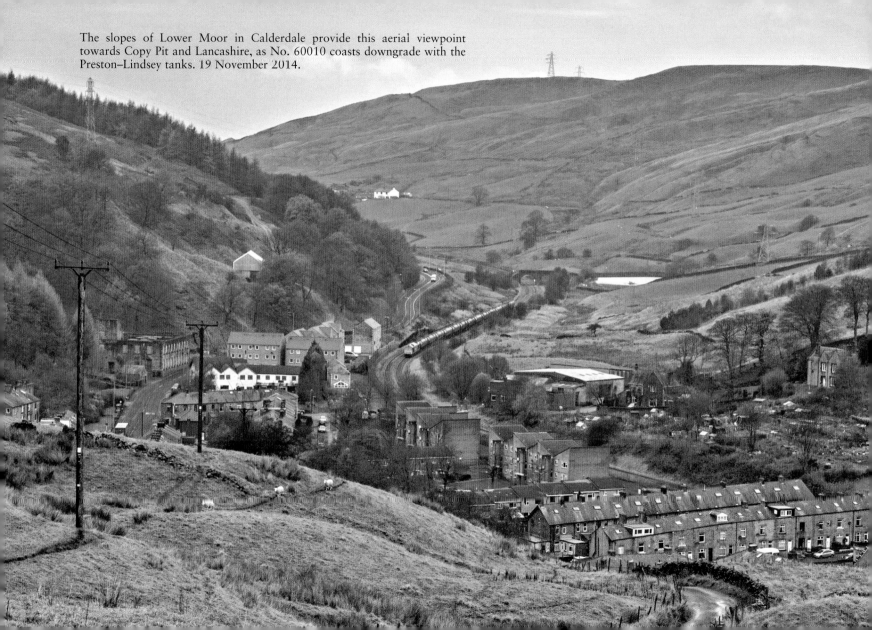

The slopes of Lower Moor in Calderdale provide this aerial viewpoint towards Copy Pit and Lancashire, as No. 60010 coasts downgrade with the Preston–Lindsey tanks. 19 November 2014.

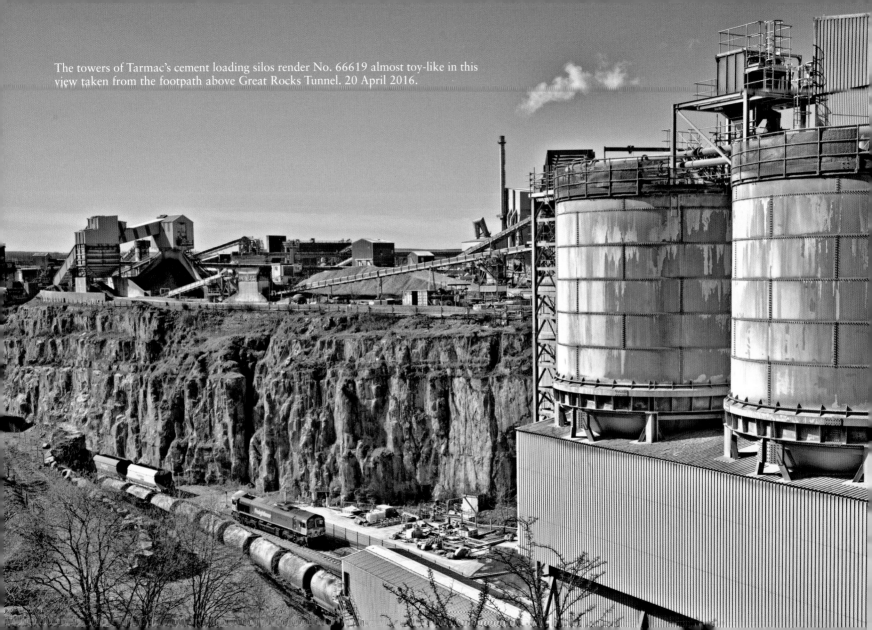

The towers of Tarmac's cement loading silos render No. 66619 almost toy-like in this view taken from the footpath above Great Rocks Tunnel. 20 April 2016.

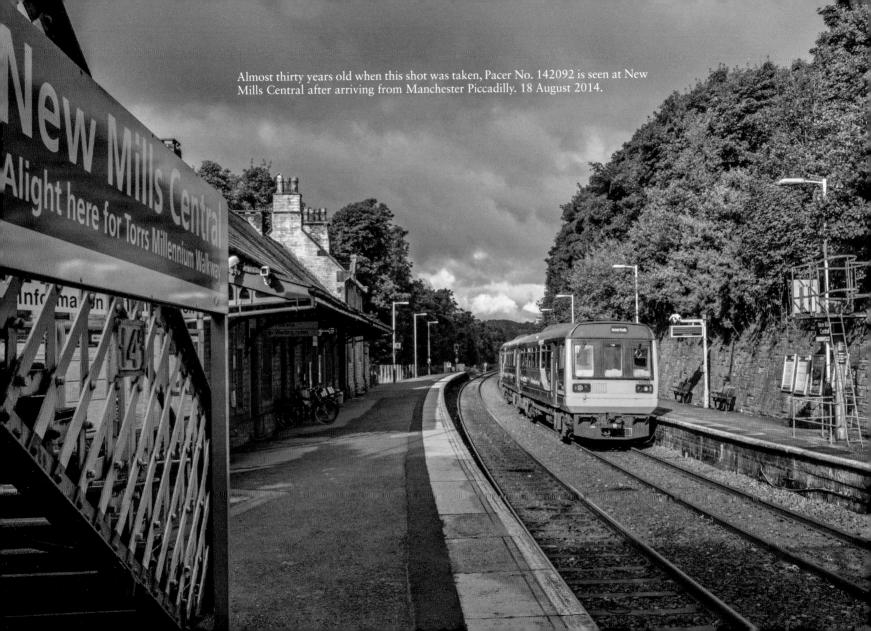

Almost thirty years old when this shot was taken, Pacer No. 142092 is seen at New Mills Central after arriving from Manchester Piccadilly. 18 August 2014.

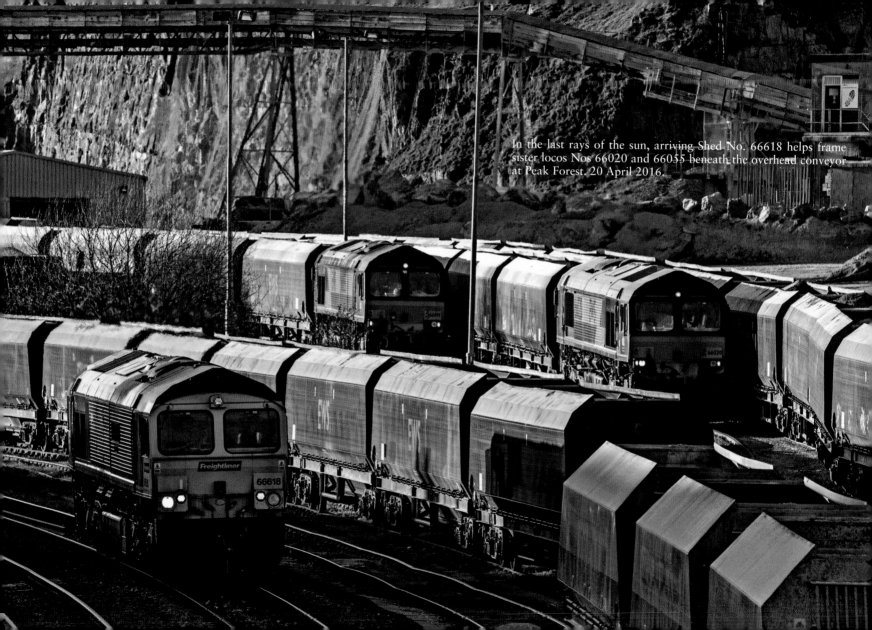

In the last rays of the sun, arriving Shed No. 66618 helps frame sister locos Nos 66020 and 66055 beneath the overhead conveyor at Peak Forest. 20 April 2016.

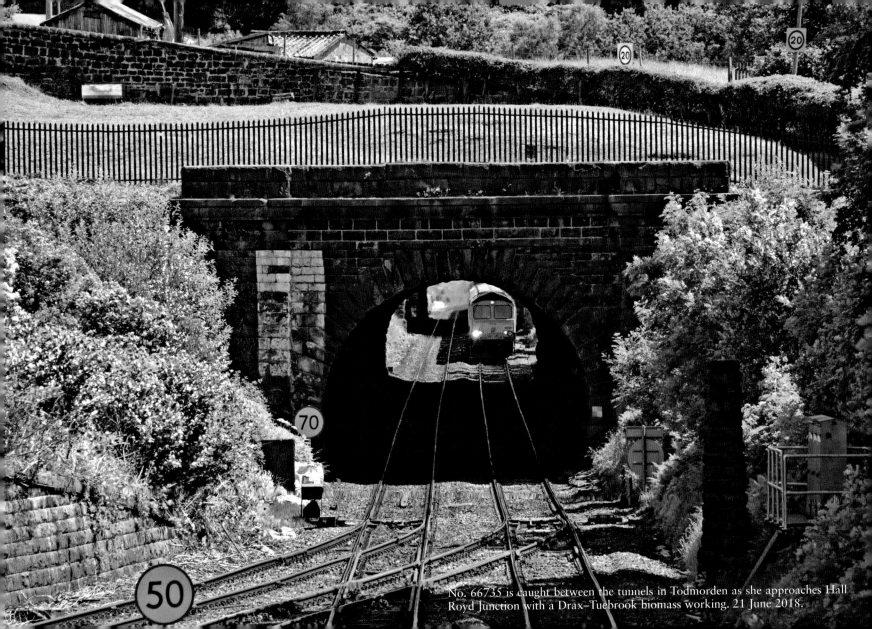

No. 66735 is caught between the tunnels in Todmorden as she approaches Hall Royd Junction with a Drax–Tuebrook biomass working. 21 June 2018.

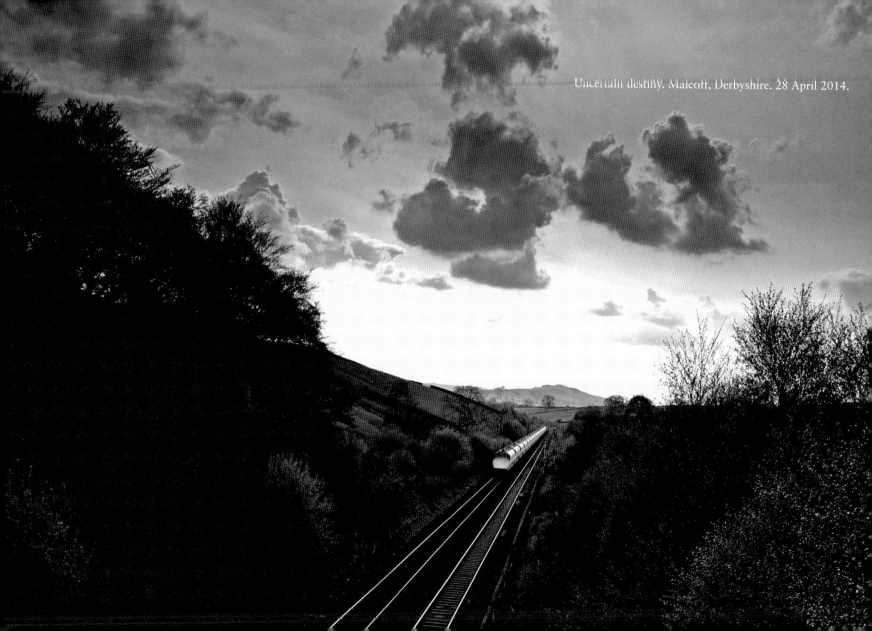

Uncertain destiny. Malcott, Derbyshire. 28 April 2014.

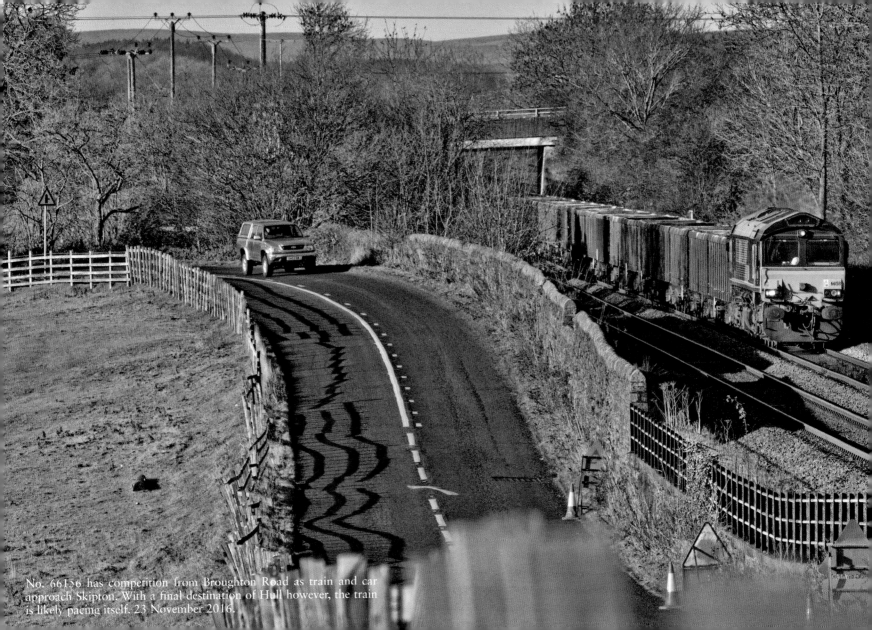

No. 66156 has competition from Broughton Road as train and car approach Skipton. With a final destination of Hull however, the train is likely pacing itself. 23 November 2016.

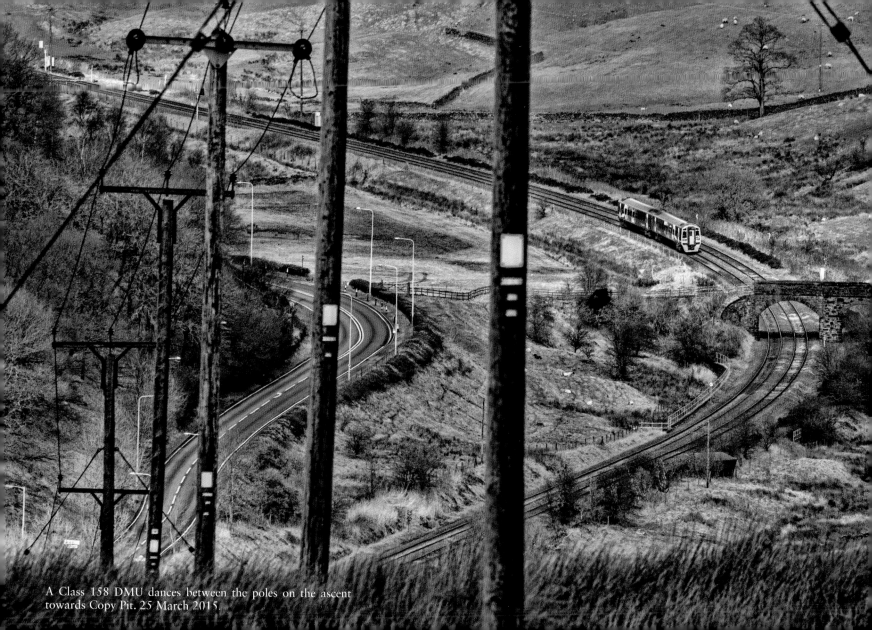

A Class 158 DMU dances between the poles on the ascent towards Copy Pit. 25 March 2015.

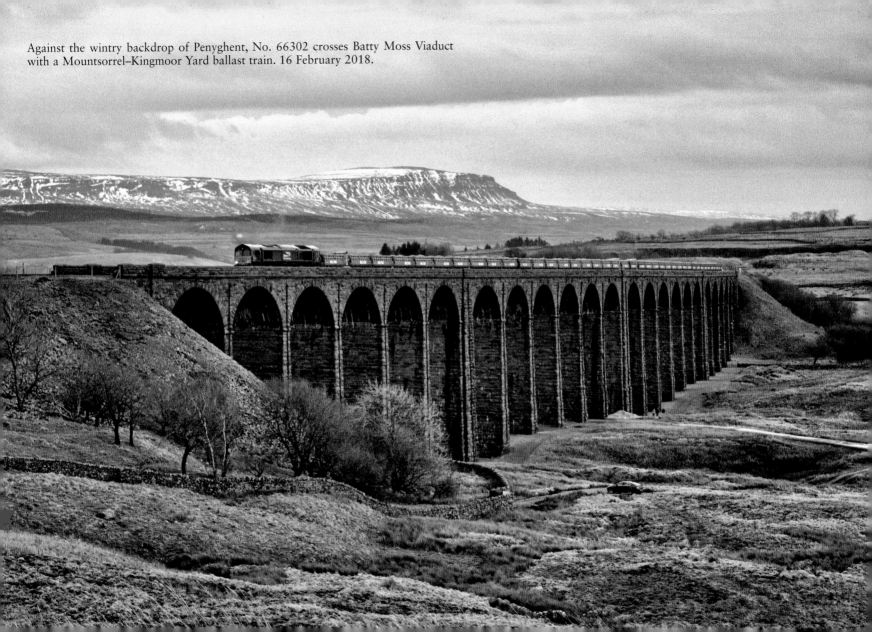

Against the wintry backdrop of Penyghent, No. 66302 crosses Batty Moss Viaduct with a Mountsorrel–Kingmoor Yard ballast train. 16 February 2018.

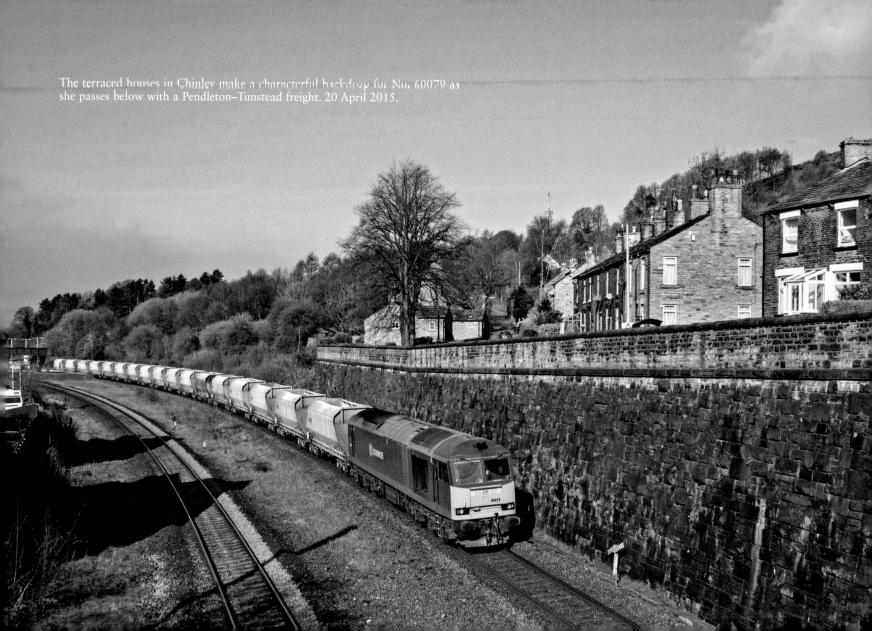

The terraced houses in Chinley make a characterful backdrop for No. 60079 as she passes below with a Pendleton–Tunstead freight. 20 April 2015.

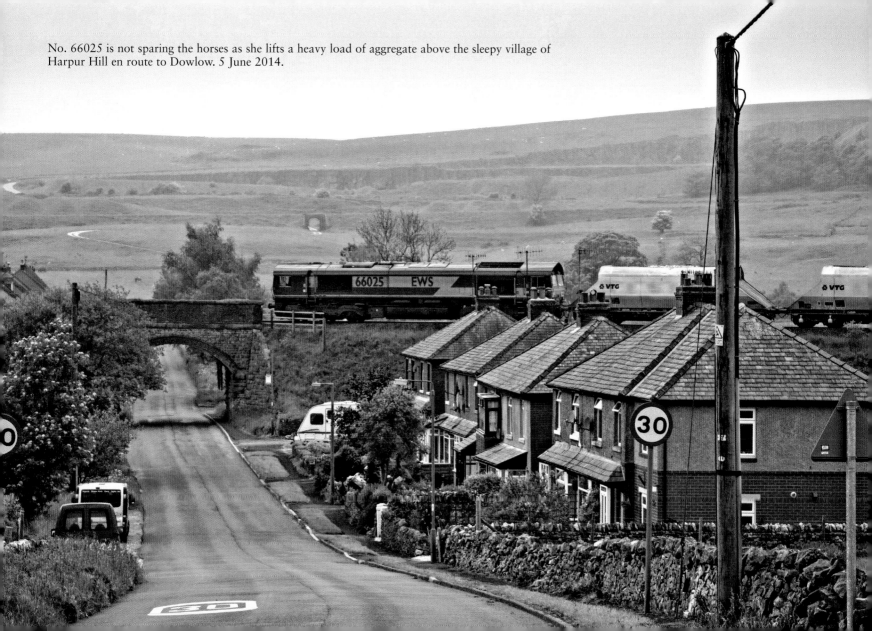

No. 66025 is not sparing the horses as she lifts a heavy load of aggregate above the sleepy village of Harpur Hill en route to Dowlow. 5 June 2014.

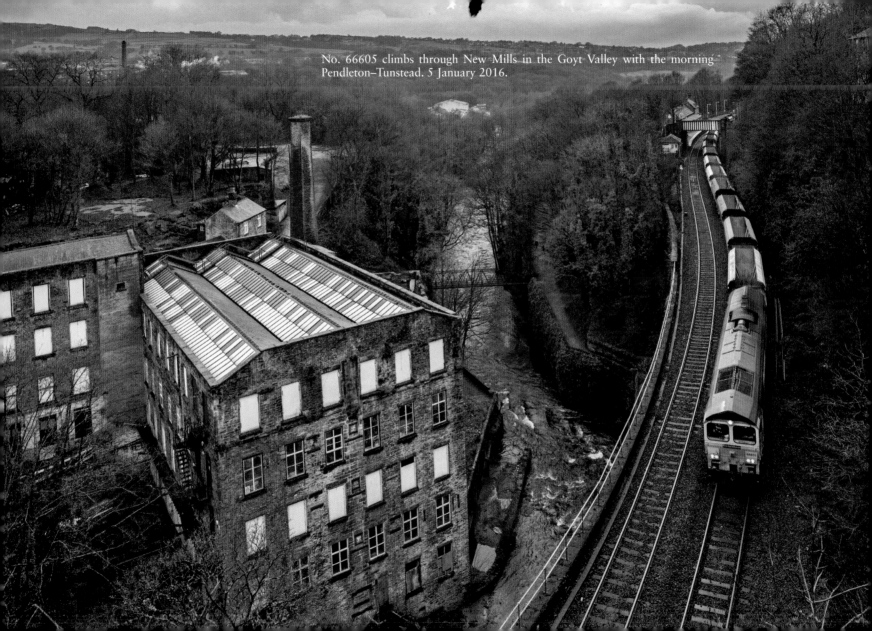

No. 66605 climbs through New Mills in the Goyt Valley with the morning Pendleton–Tunstead. 5 January 2016.

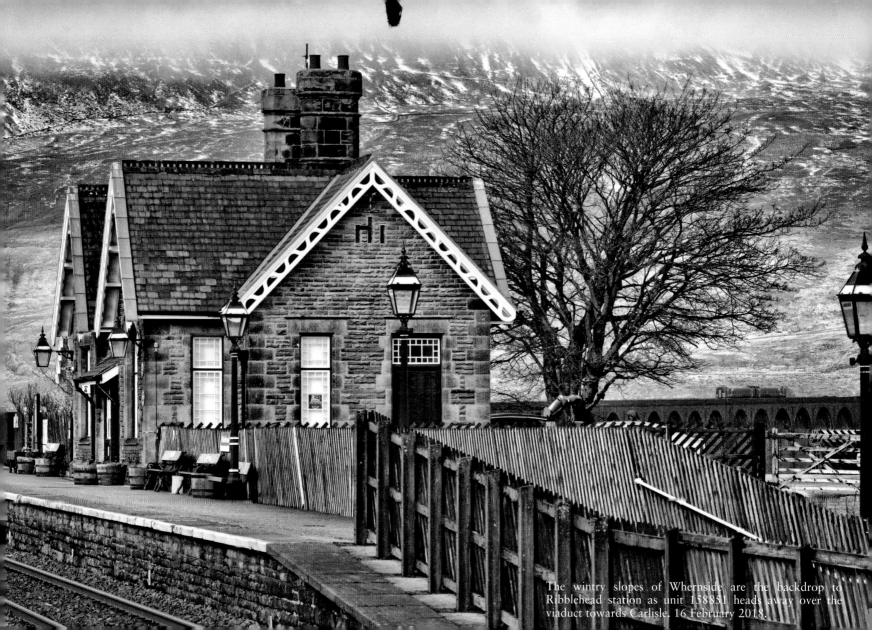

The wintry slopes of Whernside are the backdrop to Ribblehead station as unit 158851 heads away over the viaduct towards Carlisle. 16 February 2018.

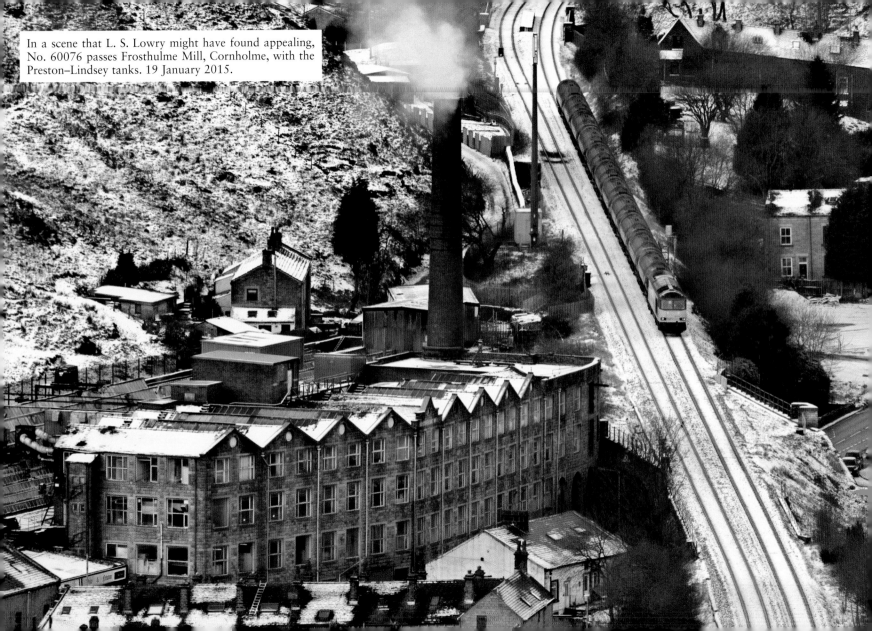

In a scene that L. S. Lowry might have found appealing, No. 60076 passes Frosthulme Mill, Cornholme, with the Preston–Lindsey tanks. 19 January 2015.

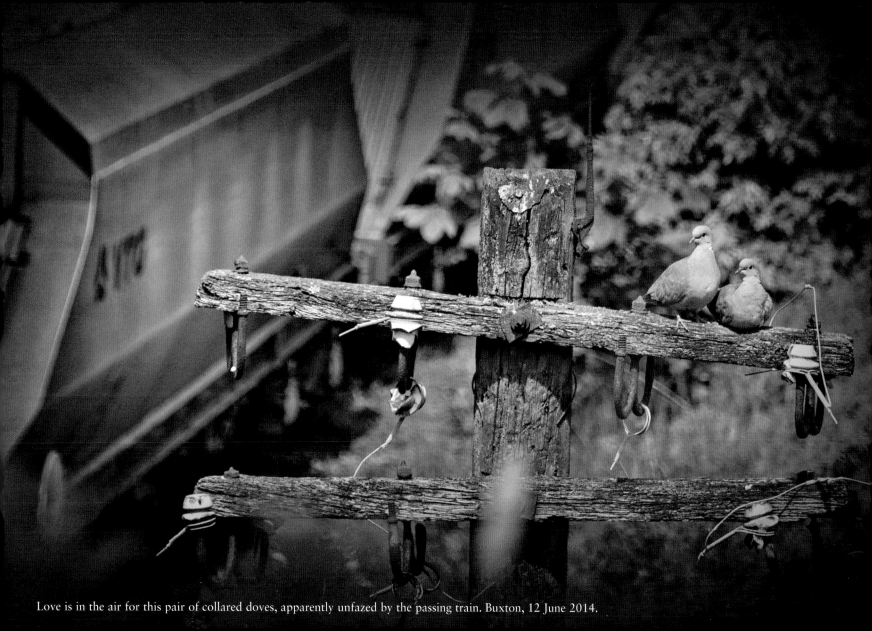

Love is in the air for this pair of collared doves, apparently unfazed by the passing train. Buxton, 12 June 2014.

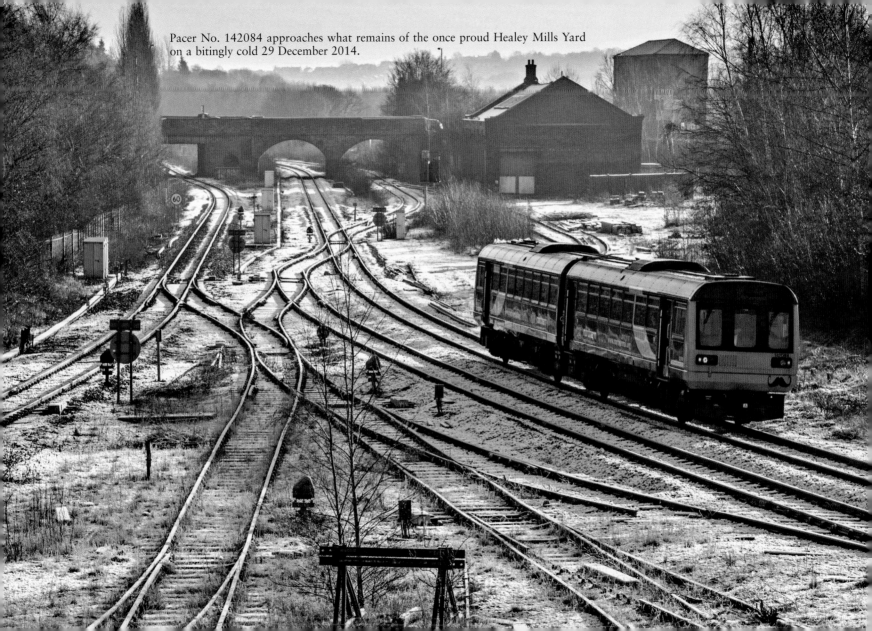

Pacer No. 142084 approaches what remains of the once proud Healey Mills Yard on a bitingly cold 29 December 2014.

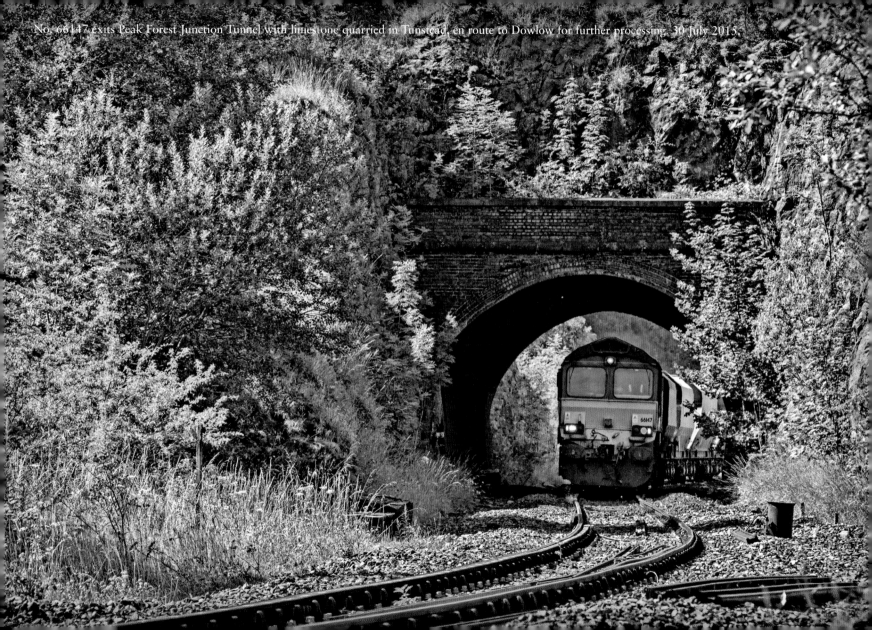

No. 66147 exits Peak Forest Junction Tunnel with limestone quarried in Tunstead, en route to Dowlow for further processing. 30 July 2015.

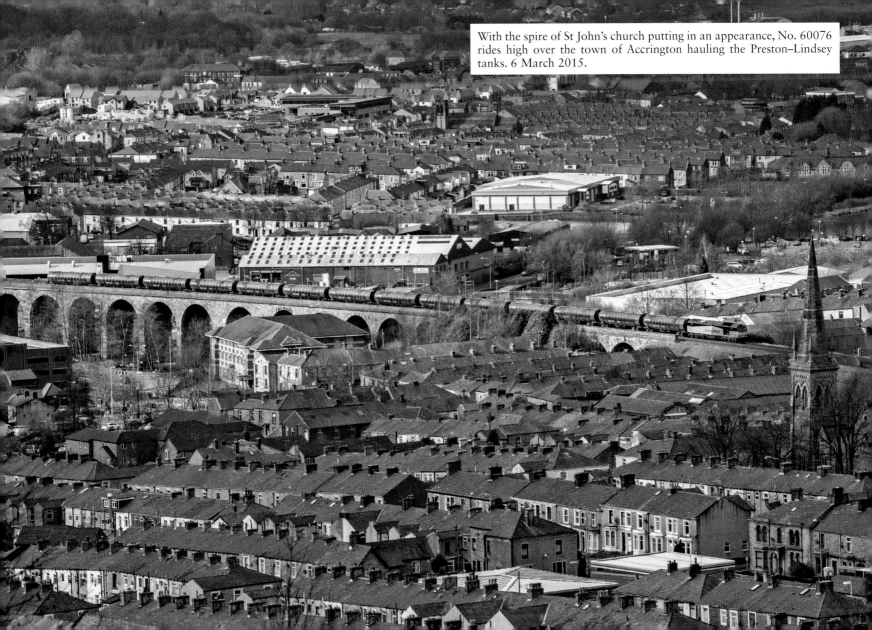

With the spire of St John's church putting in an appearance, No. 60076 rides high over the town of Accrington hauling the Preston–Lindsey tanks. 6 March 2015.

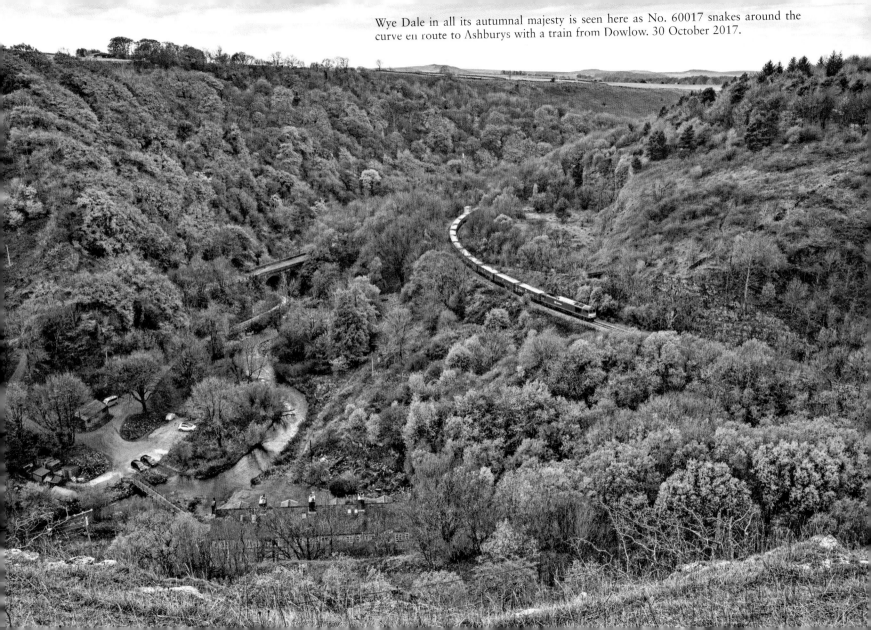

Wye Dale in all its autumnal majesty is seen here as No. 60017 snakes around the curve en route to Ashburys with a train from Dowlow. 30 October 2017.

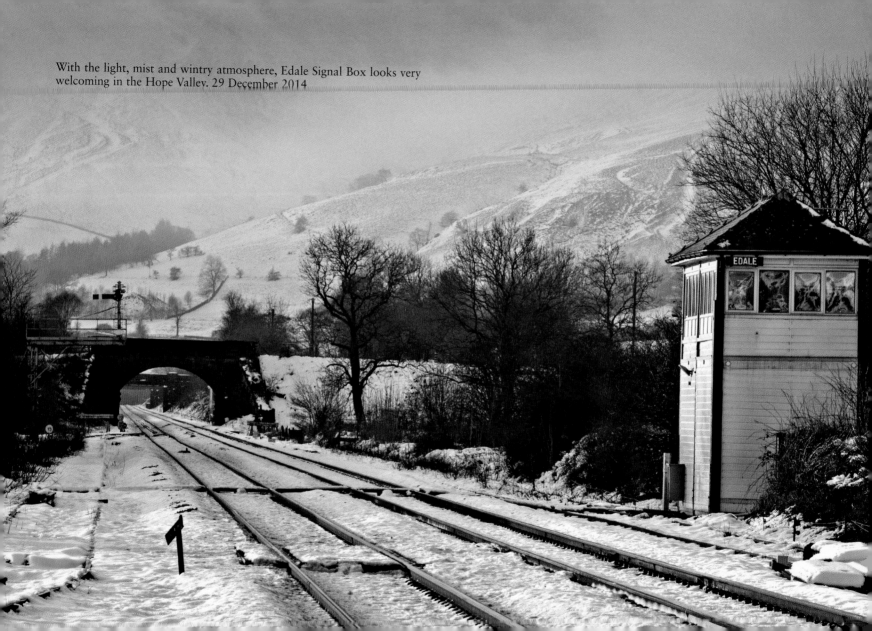

With the light, mist and wintry atmosphere, Edale Signal Box looks very welcoming in the Hope Valley. 29 December 2014

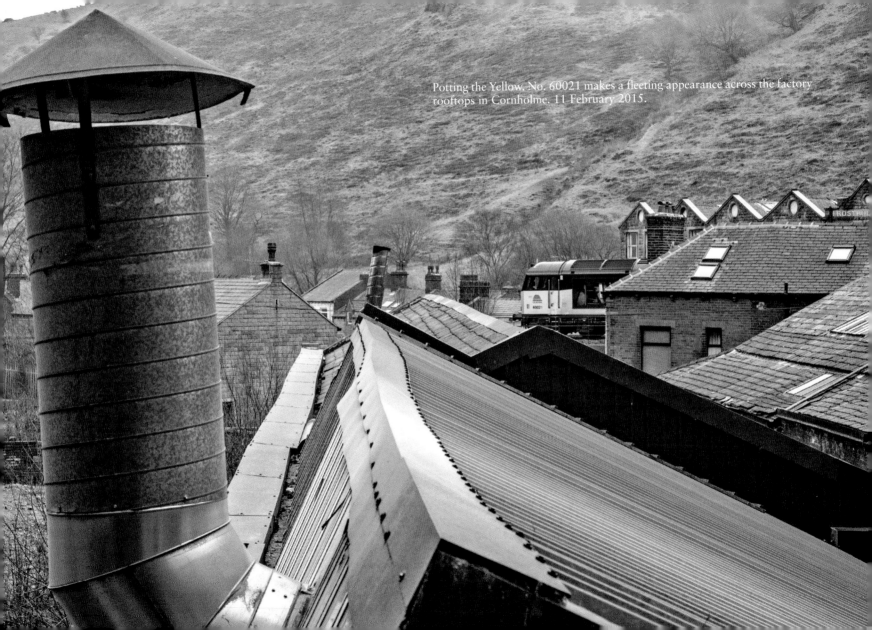

Potting the Yellow. No. 60021 makes a fleeting appearance across the factory rooftops in Cornholme. 11 February 2015.

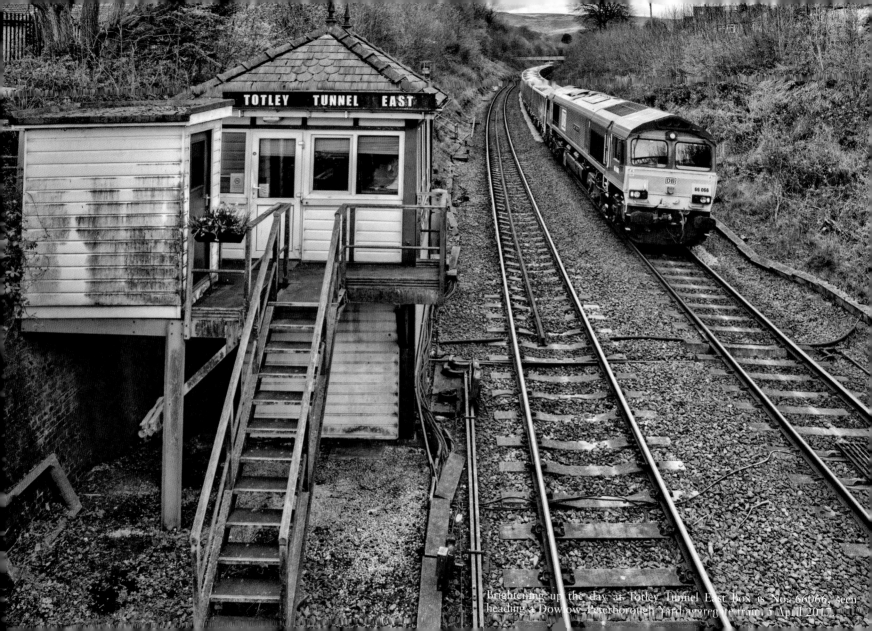

Brightening up the day at Totley Tunnel East Box is No. 66066, seen heading a Dowlow–Peterborough Yard aggregate train, 5 April 2012.

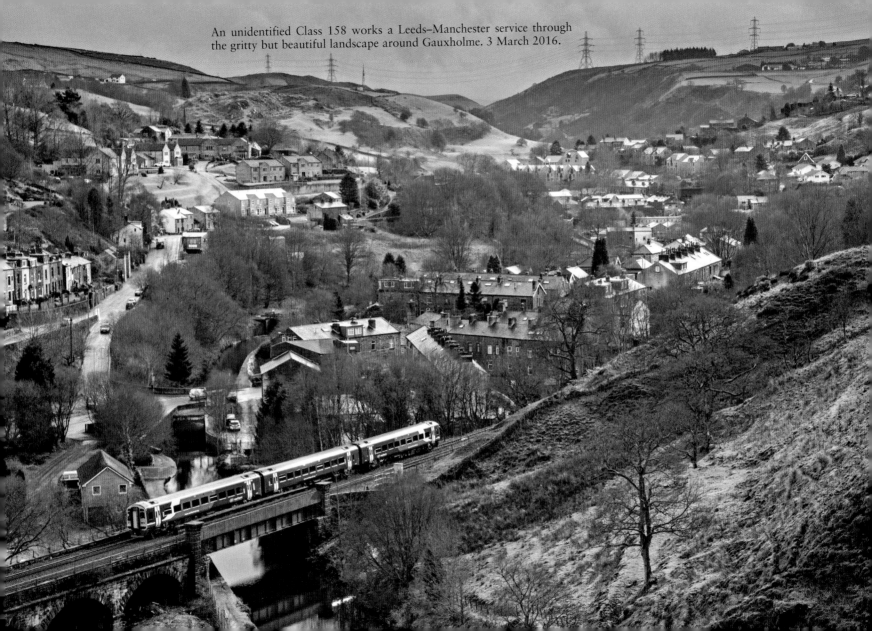

An unidentified Class 158 works a Leeds–Manchester service through the gritty but beautiful landscape around Gauxholme. 3 March 2016.

Beneath Batty Moss Viaduct a stream bubbles up to eventually combine with others and form the River Ribble. Overhead No. 60087 is seen hauling the Carlisle–Chirk log train. 16 February 2018.

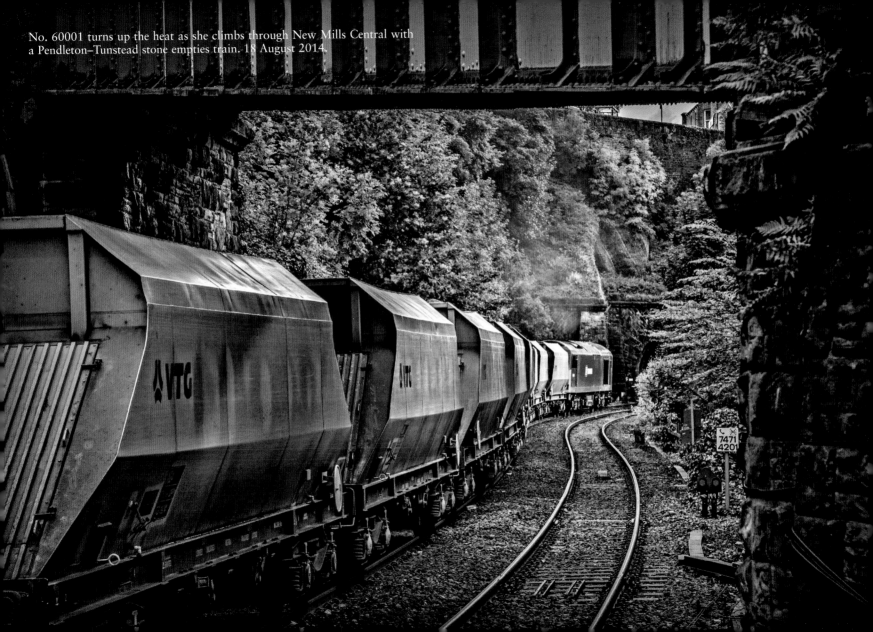

No. 60001 turns up the heat as she climbs through New Mills Central with a Pendleton–Tunstead stone empties train. 18 August 2014.

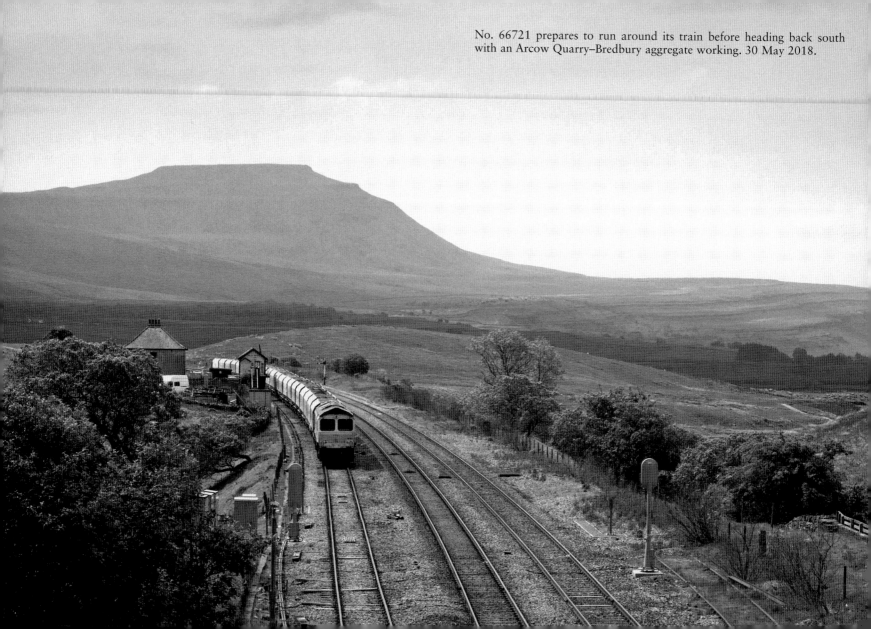

No. 66721 prepares to run around its train before heading back south with an Arcow Quarry–Bredbury aggregate working. 30 May 2018.

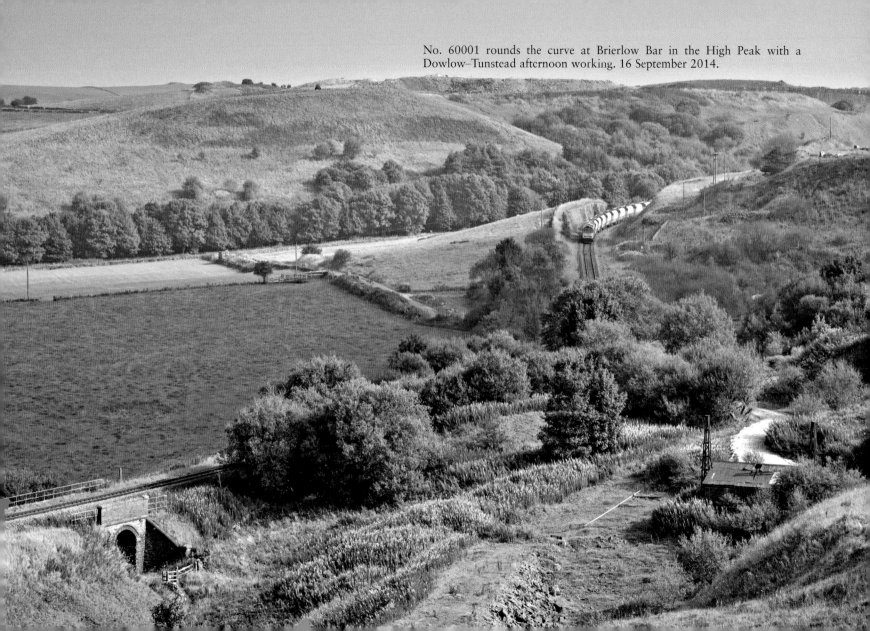

No. 60001 rounds the curve at Brierlow Bar in the High Peak with a Dowlow–Tunstead afternoon working. 16 September 2014.

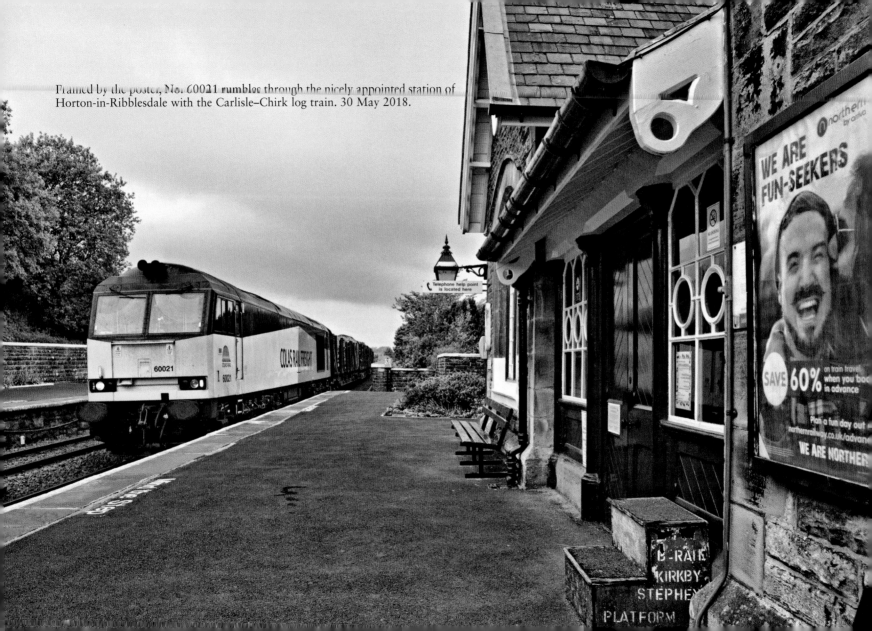

Framed by the poster, No. 60021 rumbles through the nicely appointed station of Horton-in-Ribblesdale with the Carlisle–Chirk log train. 30 May 2018.

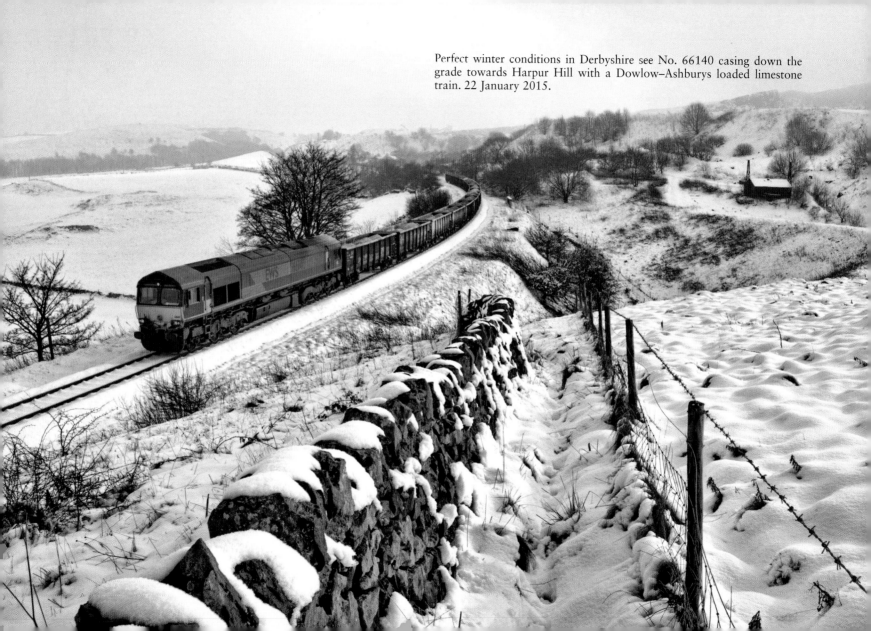

Perfect winter conditions in Derbyshire see No. 66140 casing down the grade towards Harpur Hill with a Dowlow–Ashburys loaded limestone train. 22 January 2015.

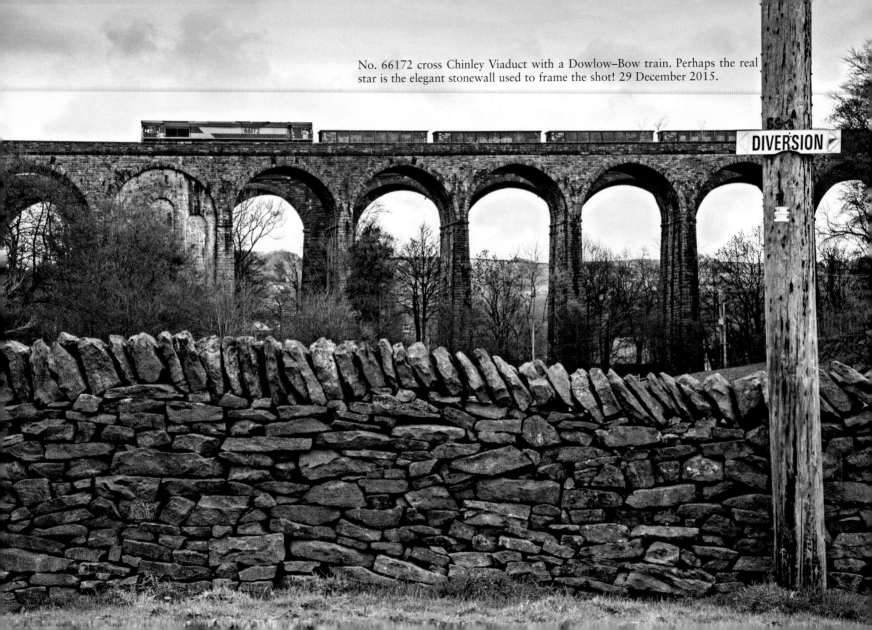

No. 66172 cross Chinley Viaduct with a Dowlow–Bow train. Perhaps the real star is the elegant stonewall used to frame the shot! 29 December 2015.

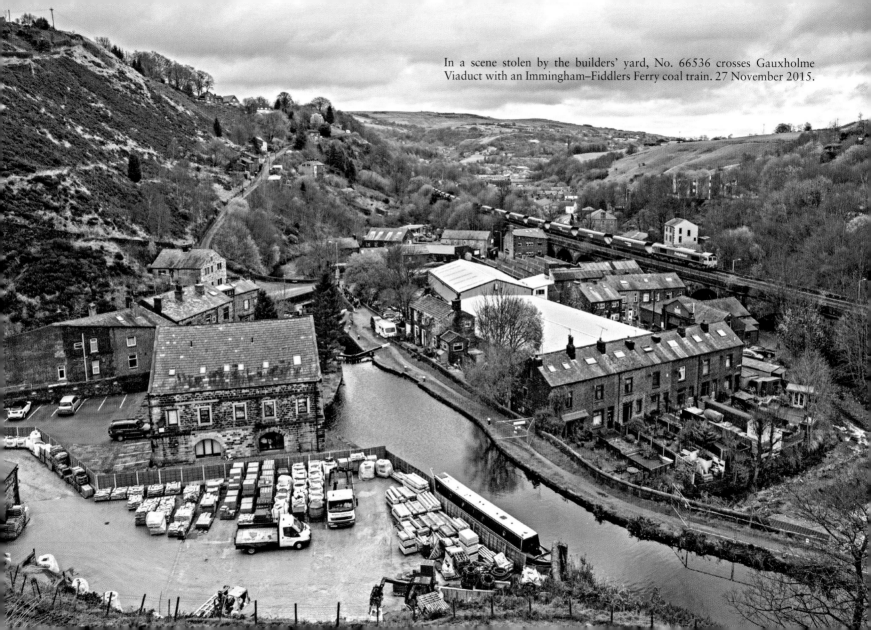

In a scene stolen by the builders' yard, No. 66536 crosses Gauxholme Viaduct with an Immingham–Fiddlers Ferry coal train. 27 November 2015.

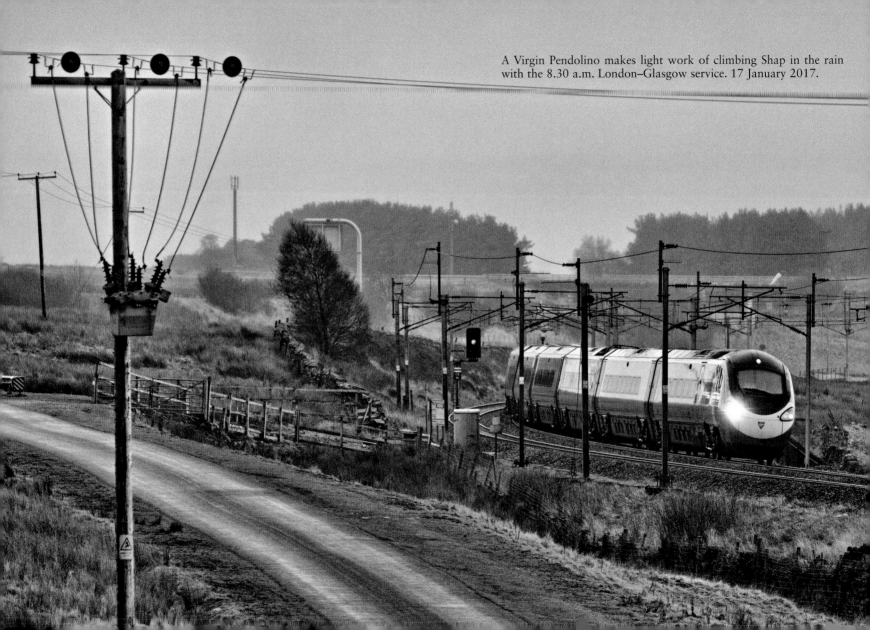

A Virgin Pendolino makes light work of climbing Shap in the rain with the 8.30 a.m. London–Glasgow service. 17 January 2017.

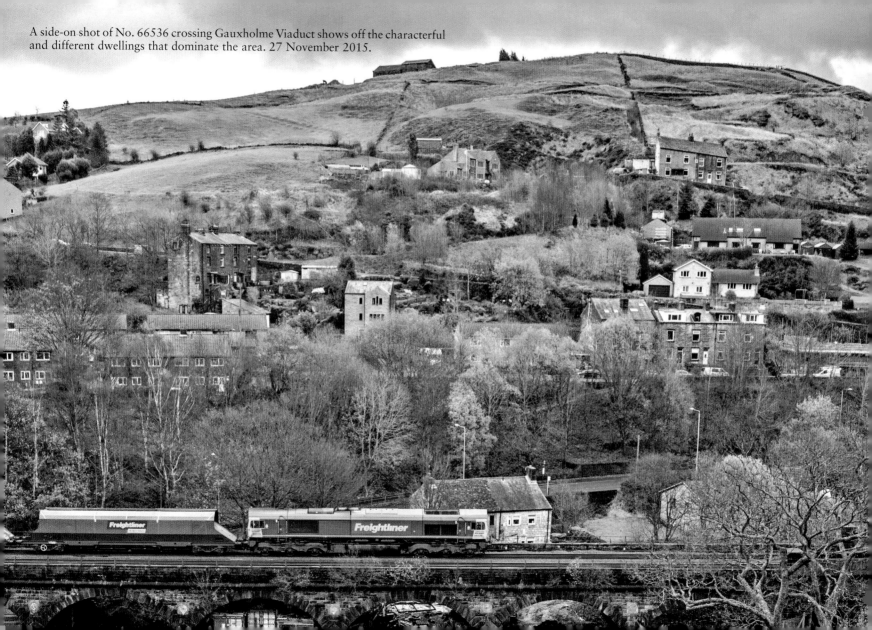

A side-on shot of No. 66536 crossing Gauxholme Viaduct shows off the characterful and different dwellings that dominate the area. 27 November 2015.

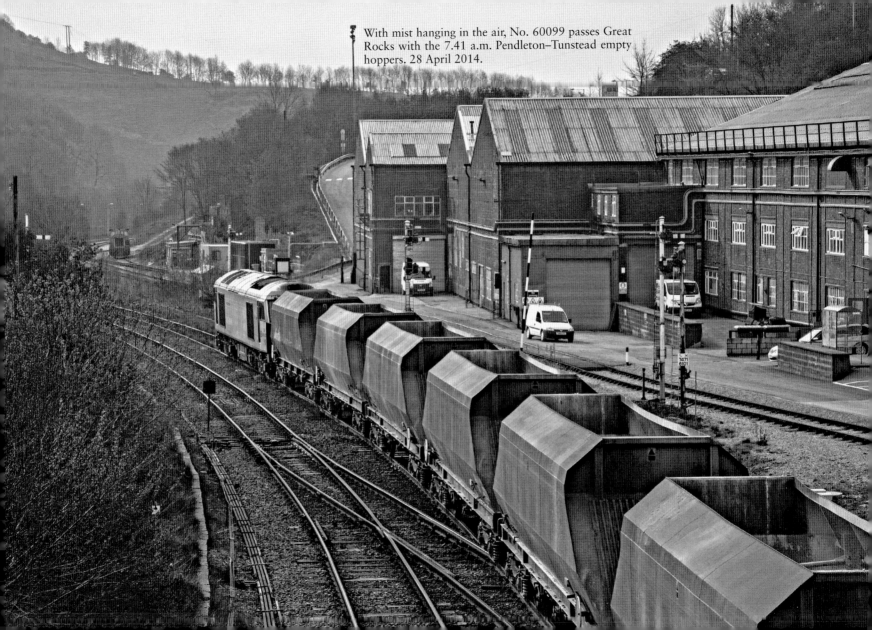

With mist hanging in the air, No. 60099 passes Great Rocks with the 7.41 a.m. Pendleton–Tunstead empty hoppers. 28 April 2014.

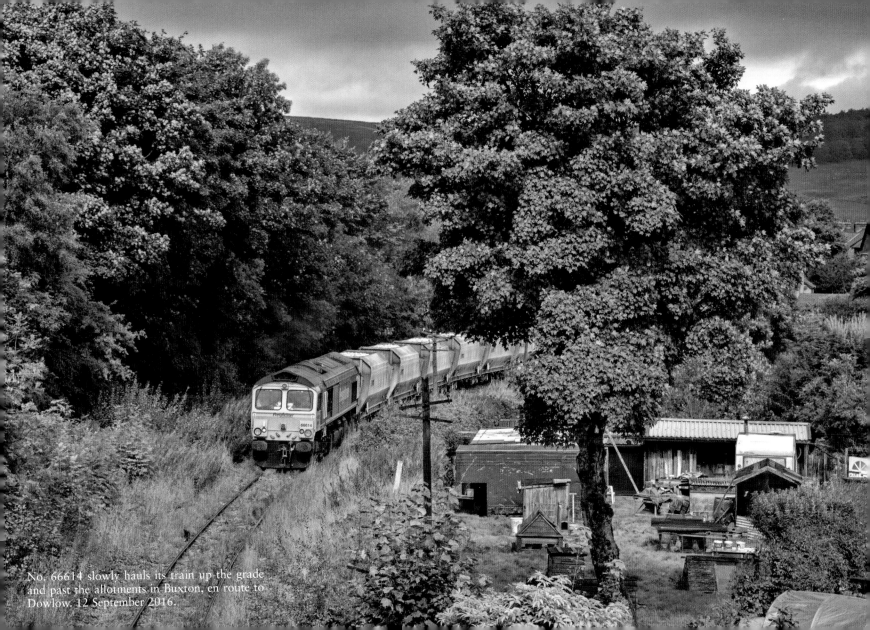

No. 66614 slowly hauls its train up the grade and past the allotments in Buxton, en route to Dowlow. 12 September 2016.

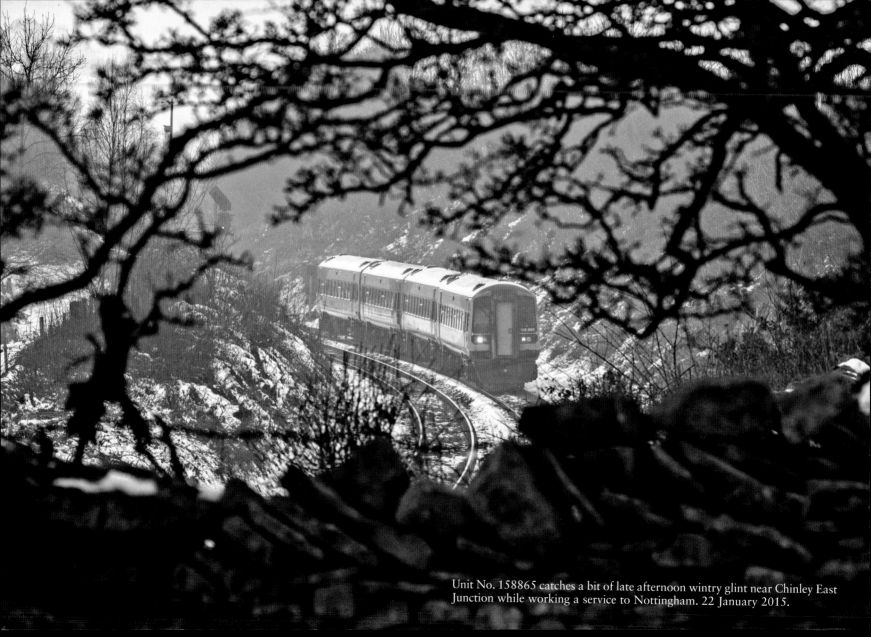

Unit No. 158865 catches a bit of late afternoon wintry glint near Chinley East Junction while working a service to Nottingham. 22 January 2015.

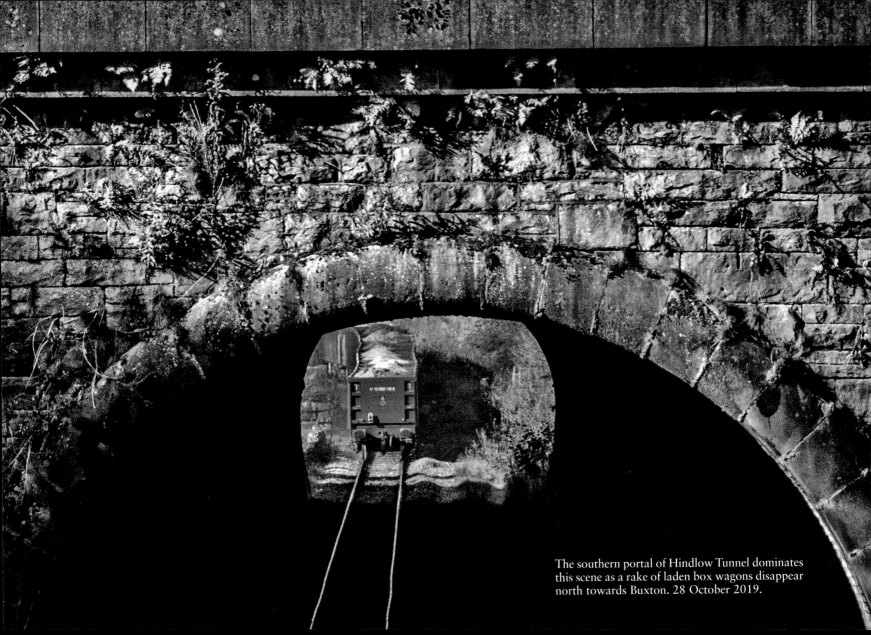

The southern portal of Hindlow Tunnel dominates this scene as a rake of laden box wagons disappear north towards Buxton. 28 October 2019.

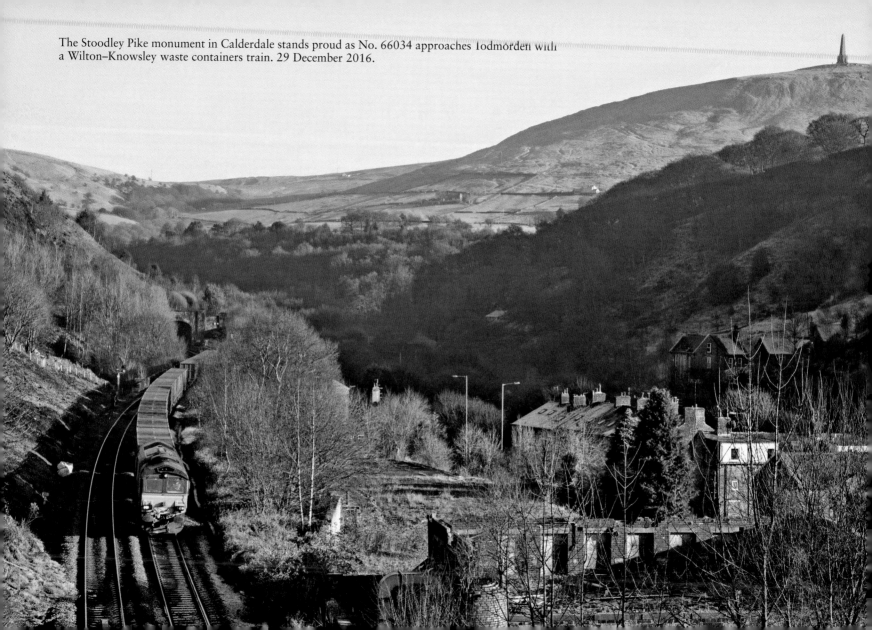

The Stoodley Pike monument in Calderdale stands proud as No. 66034 approaches Todmorden with a Wilton–Knowsley waste containers train. 29 December 2016.

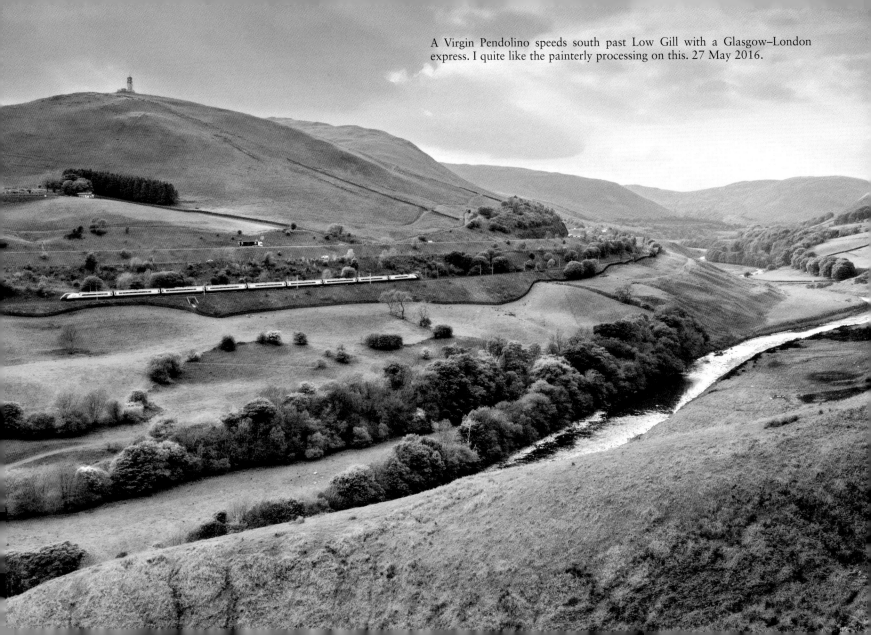

A Virgin Pendolino speeds south past Low Gill with a Glasgow–London express. I quite like the painterly processing on this. 27 May 2016.

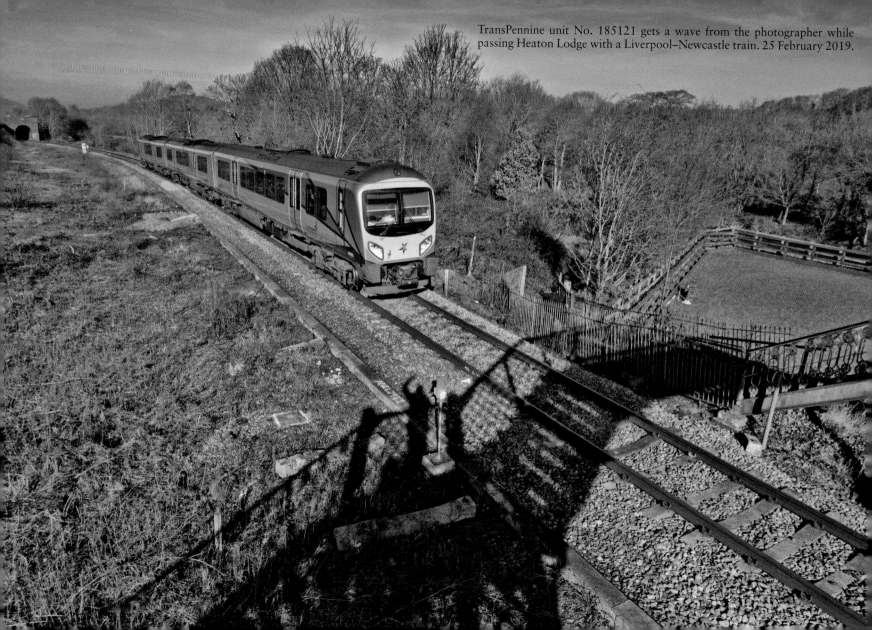

TransPennine unit No. 185121 gets a wave from the photographer while passing Heaton Lodge with a Liverpool–Newcastle train. 25 February 2019.

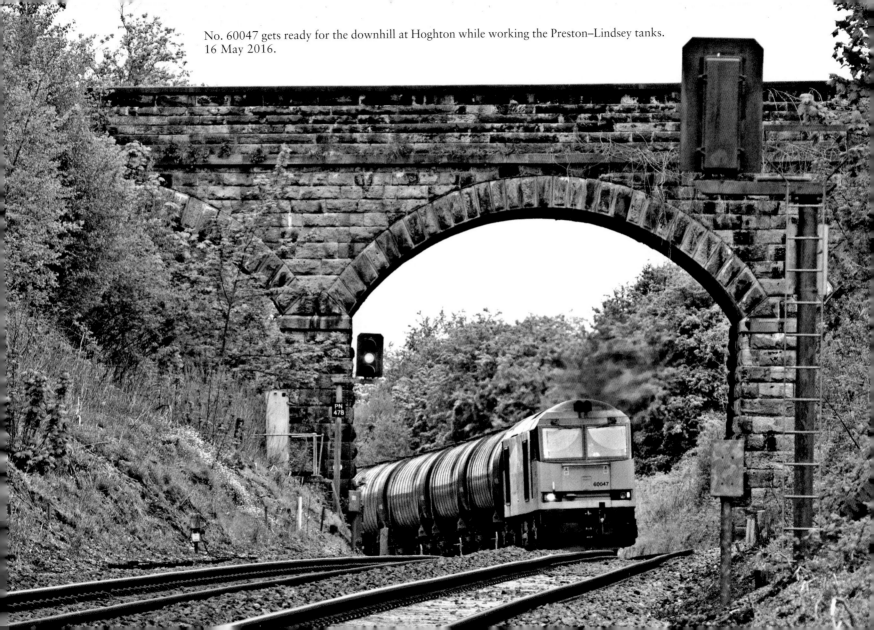
No. 60047 gets ready for the downhill at Hoghton while working the Preston–Lindsey tanks. 16 May 2016.

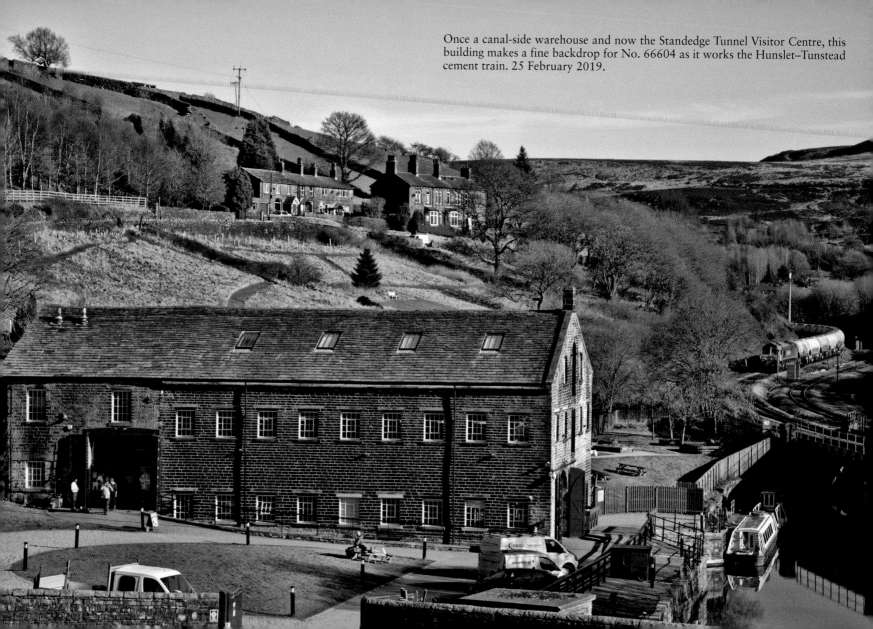

Once a canal-side warehouse and now the Standedge Tunnel Visitor Centre, this building makes a fine backdrop for No. 66604 as it works the Hunslet–Tunstead cement train. 25 February 2019.

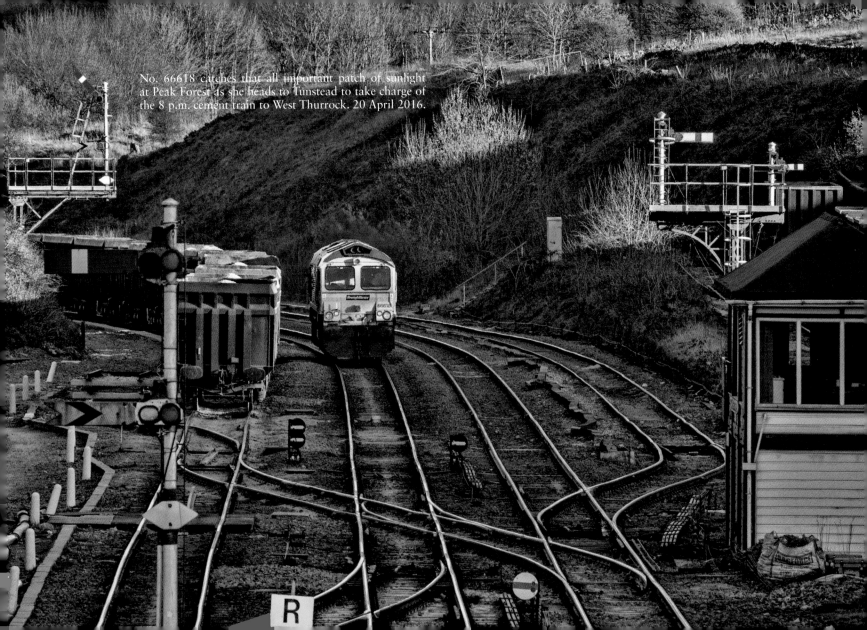

No. 66618 catches that all important patch of sunlight at Peak Forest as she heads to Tunstead to take charge of the 8 p.m. cement train to West Thurrock. 20 April 2016.

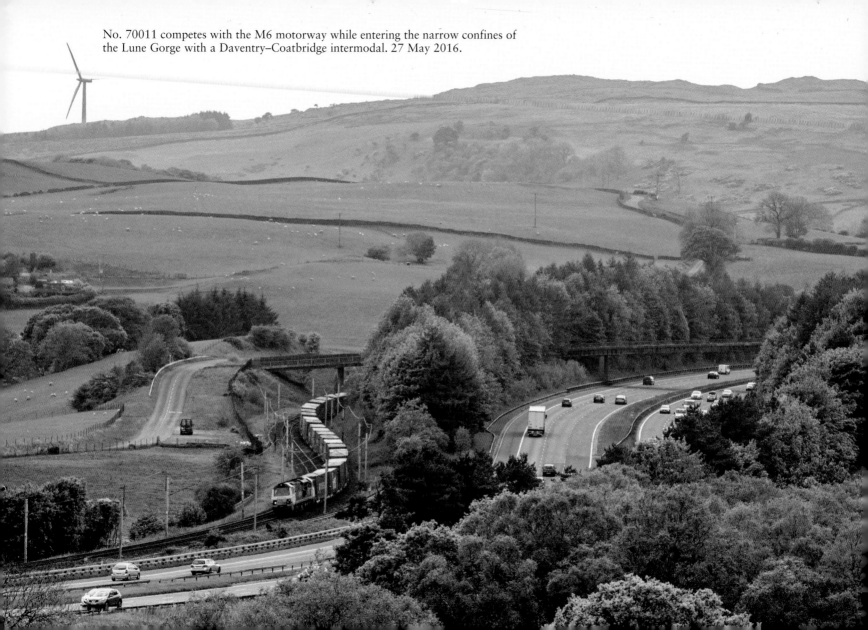

No. 70011 competes with the M6 motorway while entering the narrow confines of the Lune Gorge with a Daventry–Coatbridge intermodal. 27 May 2016.

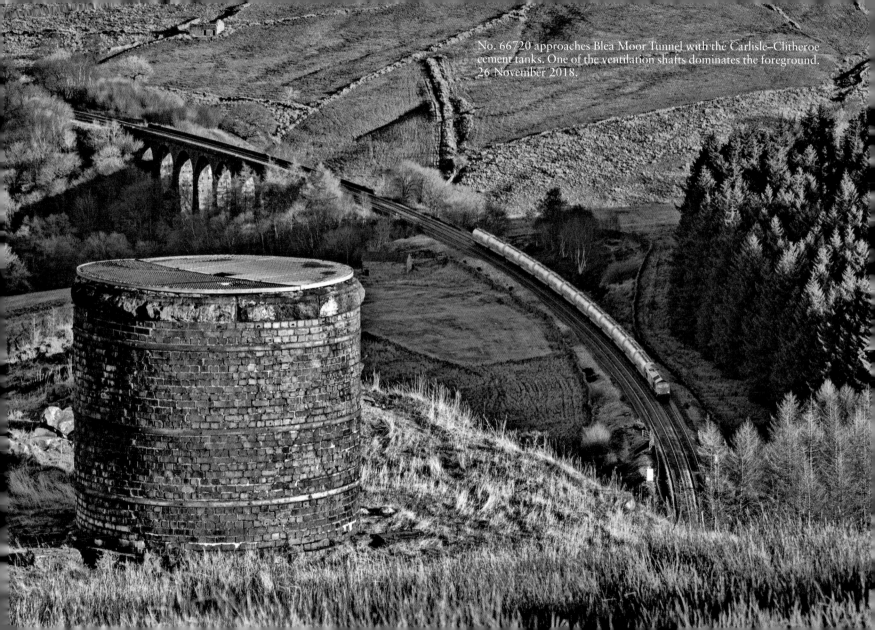

No. 66720 approaches Blea Moor Tunnel with the Carlisle–Clitheroe cement tanks. One of the ventilation shafts dominates the foreground. 26 November 2018.

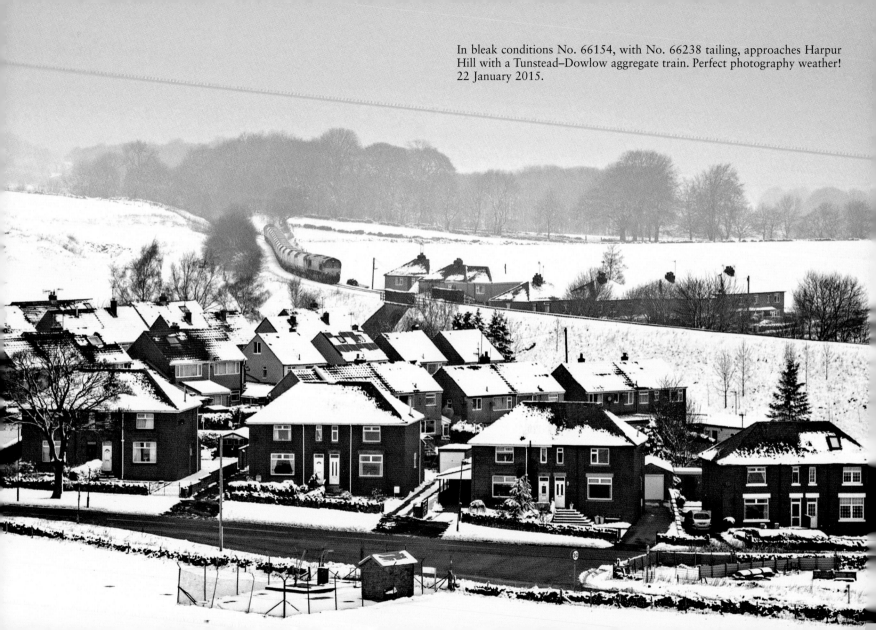

In bleak conditions No. 66154, with No. 66238 tailing, approaches Harpur Hill with a Tunstead–Dowlow aggregate train. Perfect photography weather! 22 January 2015.

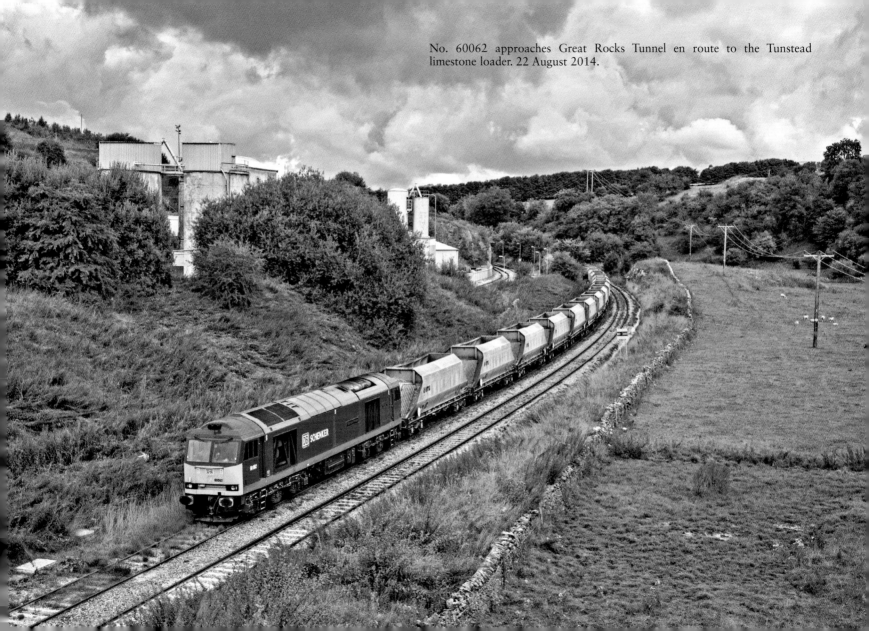

No. 60062 approaches Great Rocks Tunnel en route to the Tunstead limestone loader. 22 August 2014.

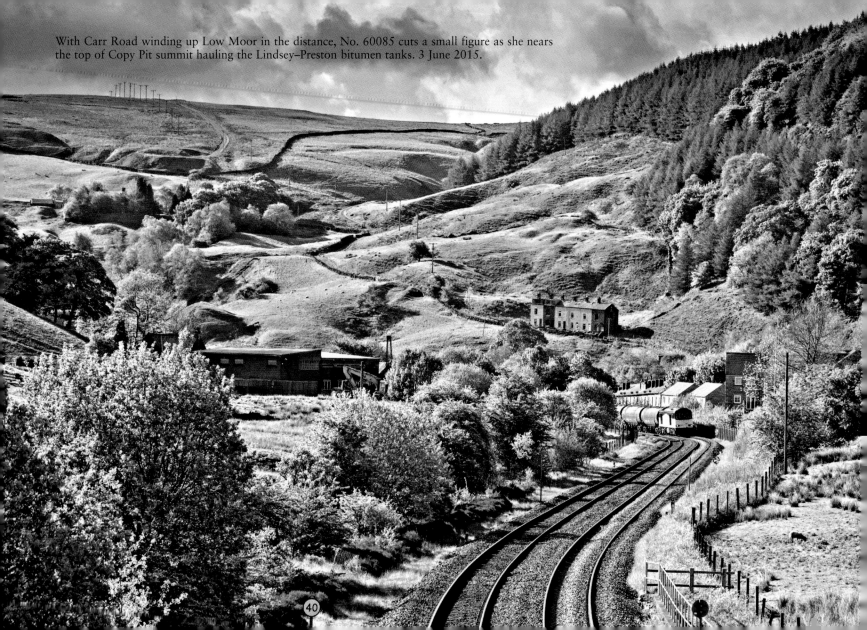

With Carr Road winding up Low Moor in the distance, No. 60085 cuts a small figure as she nears the top of Copy Pit summit hauling the Lindsey–Preston bitumen tanks. 3 June 2015.

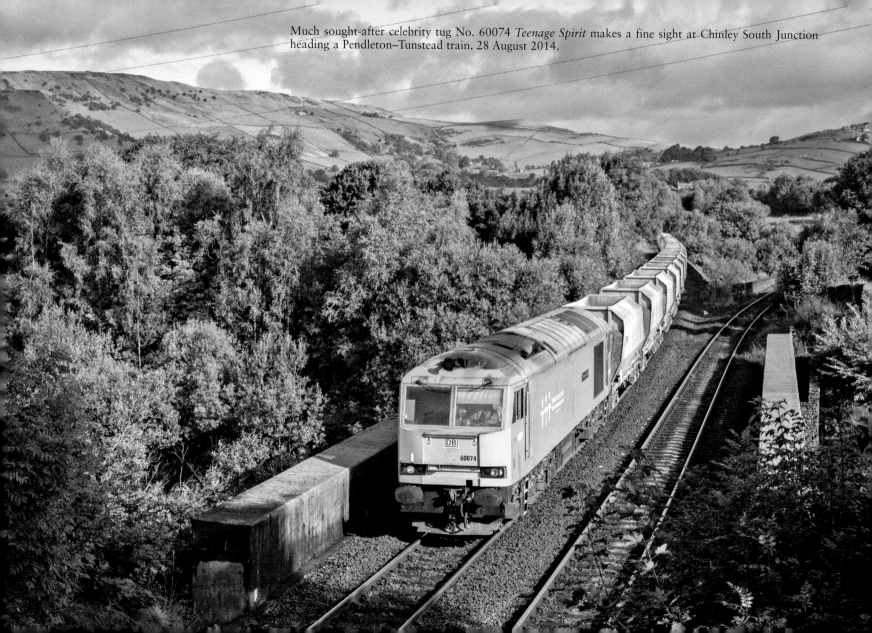

Much sought-after celebrity tug No. 60074 *Teenage Spirit* makes a fine sight at Chinley South Junction heading a Pendleton–Tunstead train. 28 August 2014.

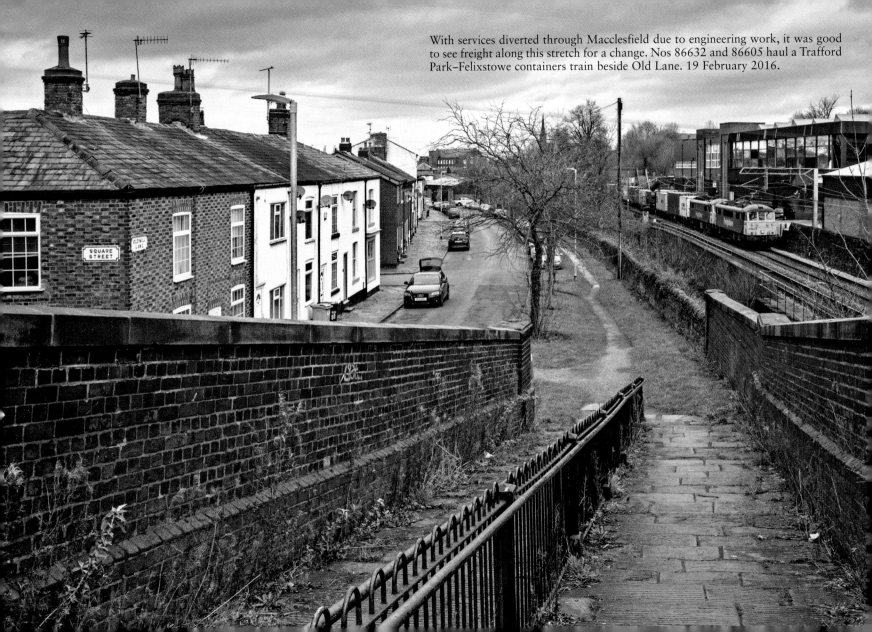

With services diverted through Macclesfield due to engineering work, it was good to see freight along this stretch for a change. Nos 86632 and 86605 haul a Trafford Park–Felixstowe containers train beside Old Lane. 19 February 2016.

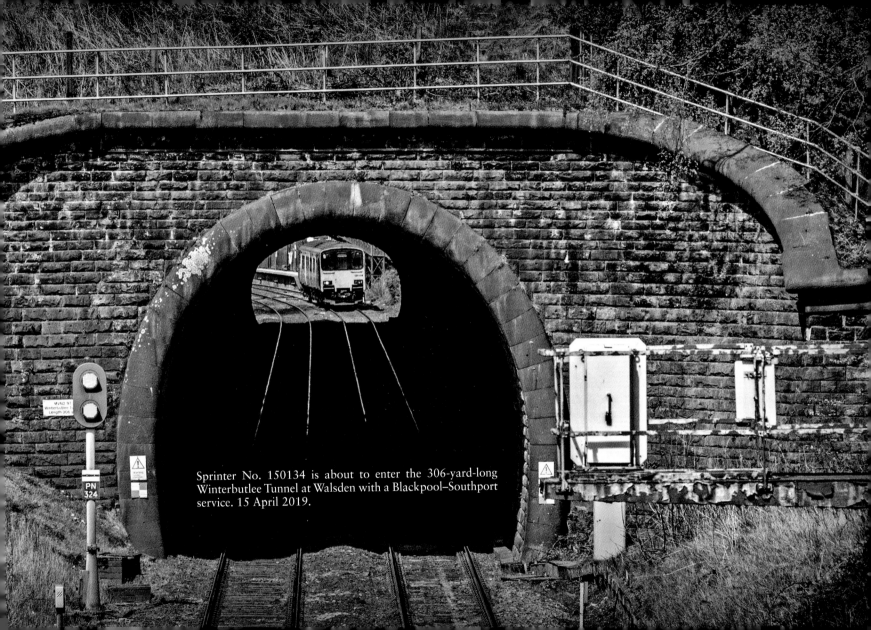

Sprinter No. 150134 is about to enter the 306-yard-long Winterbutlee Tunnel at Walsden with a Blackpool–Southport service. 15 April 2019.

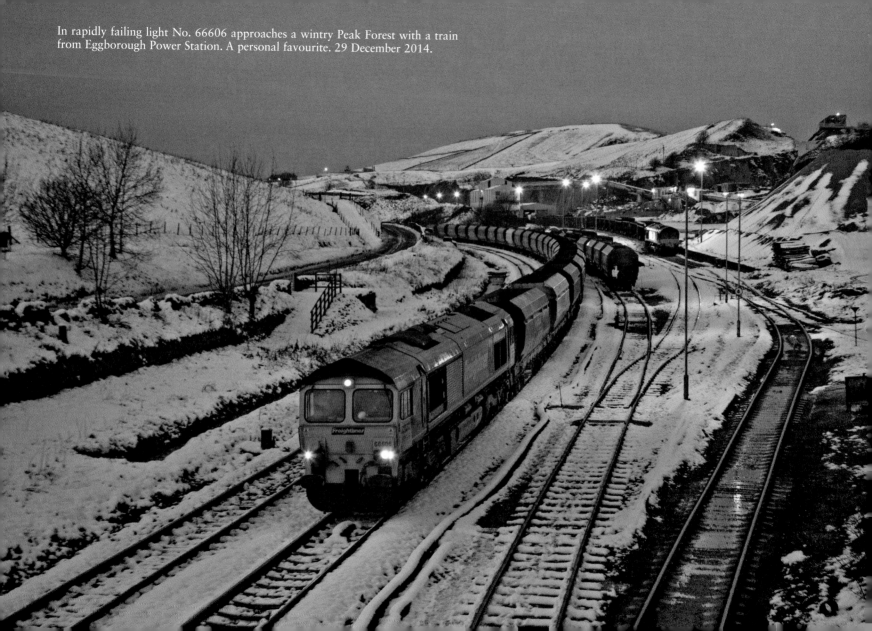

In rapidly failing light No. 66606 approaches a wintry Peak Forest with a train from Eggborough Power Station. A personal favourite. 29 December 2014.

Waiting for the Hogwarts Express? The viaduct at Dukes Drive in Buxton. 18 August 2014.

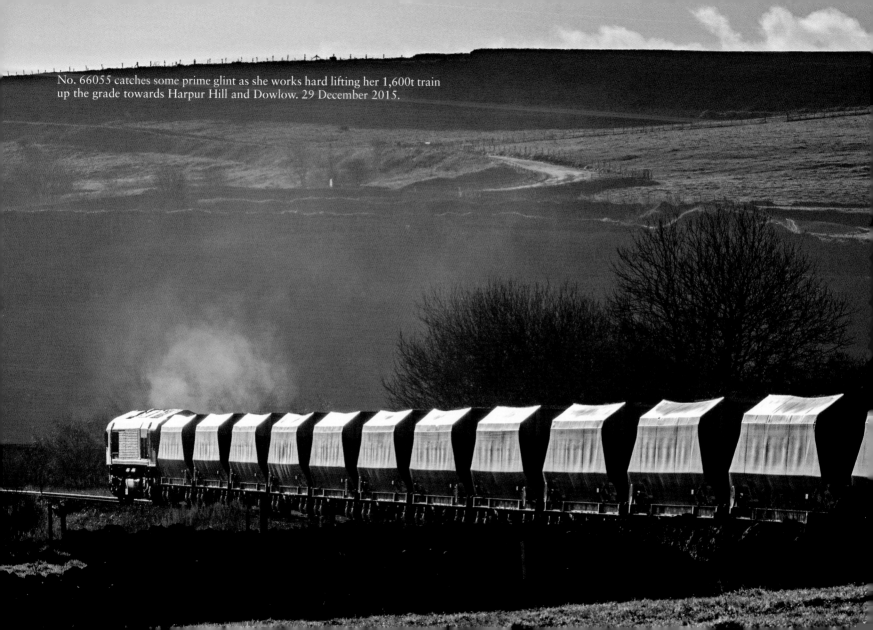

No. 66055 catches some prime glint as she works hard lifting her 1,600t train up the grade towards Harpur Hill and Dowlow. 29 December 2015.

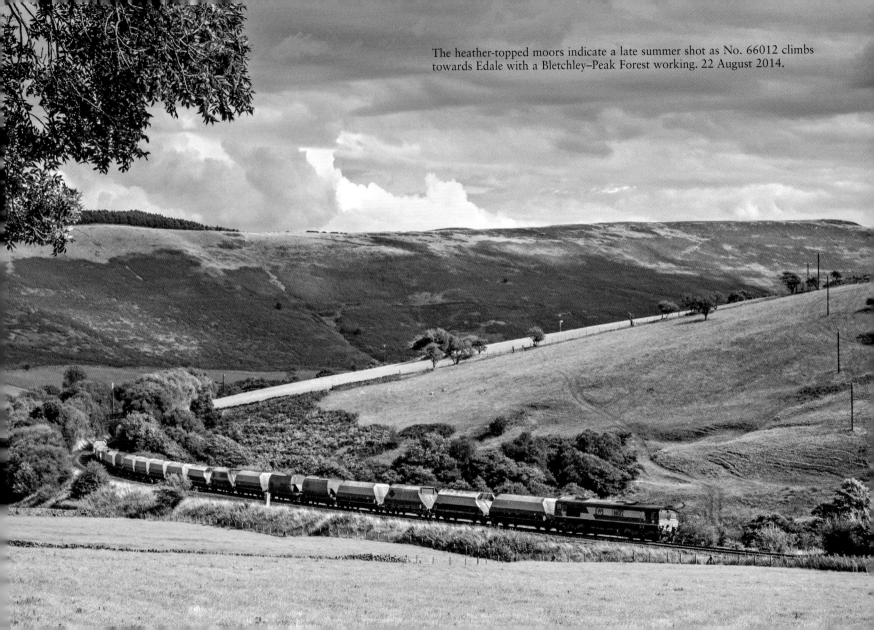

The heather-topped moors indicate a late summer shot as No. 66012 climbs towards Edale with a Bletchley–Peak Forest working. 22 August 2014.

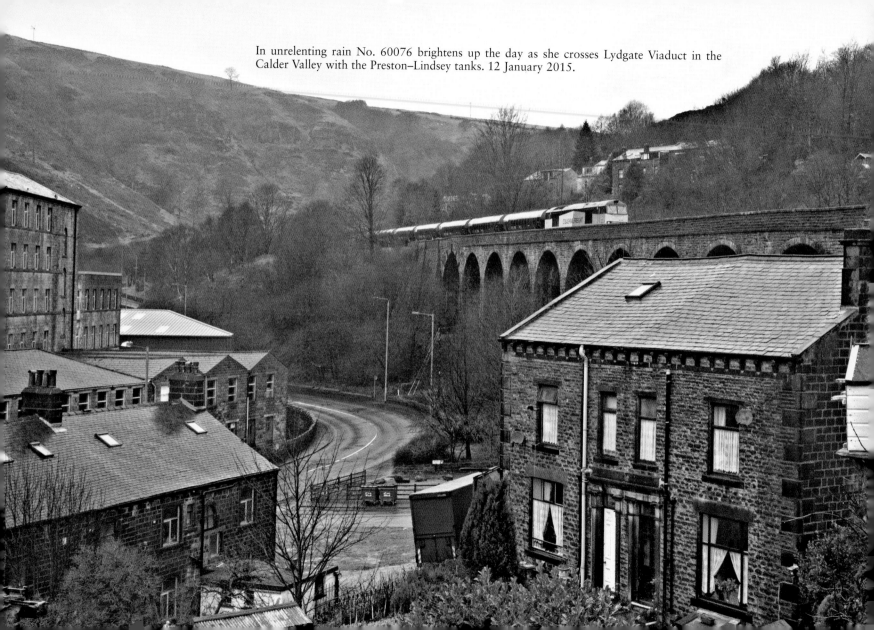

In unrelenting rain No. 60076 brightens up the day as she crosses Lydgate Viaduct in the Calder Valley with the Preston–Lindsey tanks. 12 January 2015.

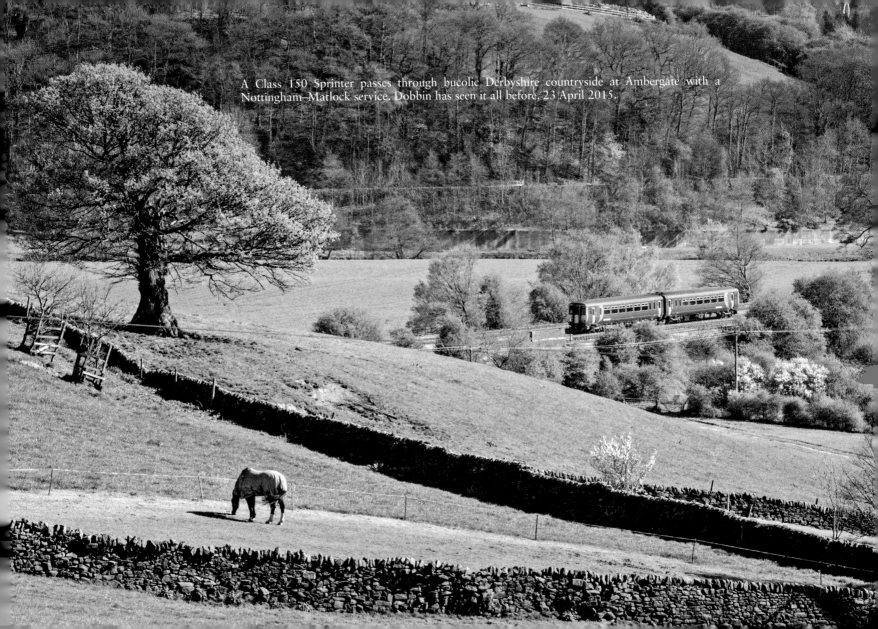

A Class 150 Sprinter passes through bucolic Derbyshire countryside at Ambergate with a Nottingham–Matlock service. Dobbin has seen it all before, 23 April 2015.

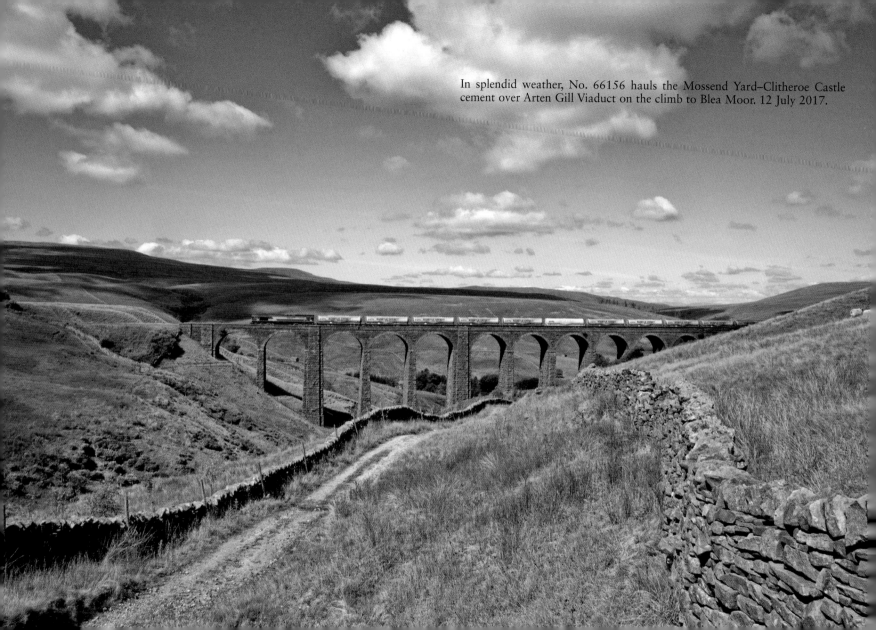

In splendid weather, No. 66156 hauls the Mossend Yard–Clitheroe Castle cement over Arten Gill Viaduct on the climb to Blea Moor. 12 July 2017.

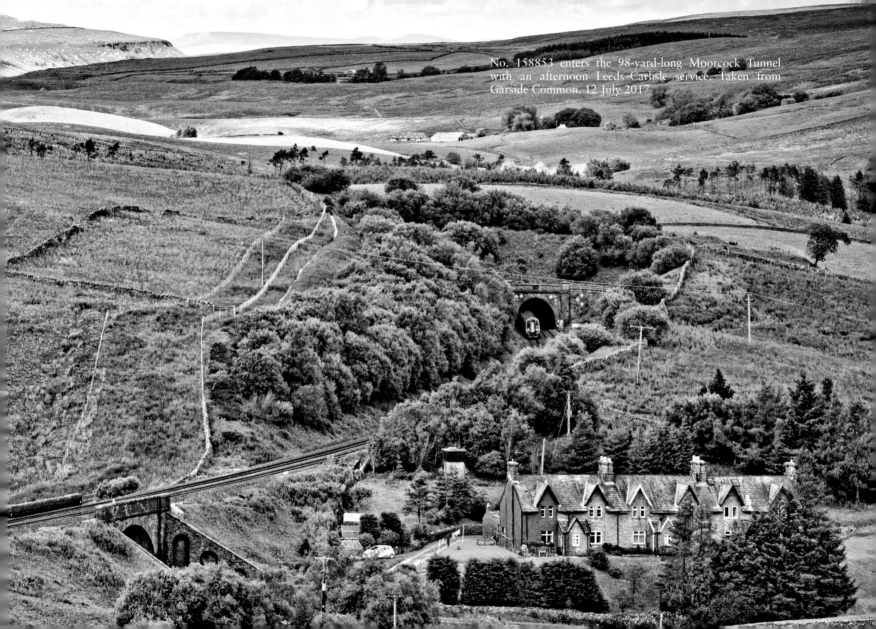

No. 158853 enters the 98-yard-long Moorcock Tunnel with an afternoon Leeds–Carlisle service. Taken from Garside Common, 12 July 2017

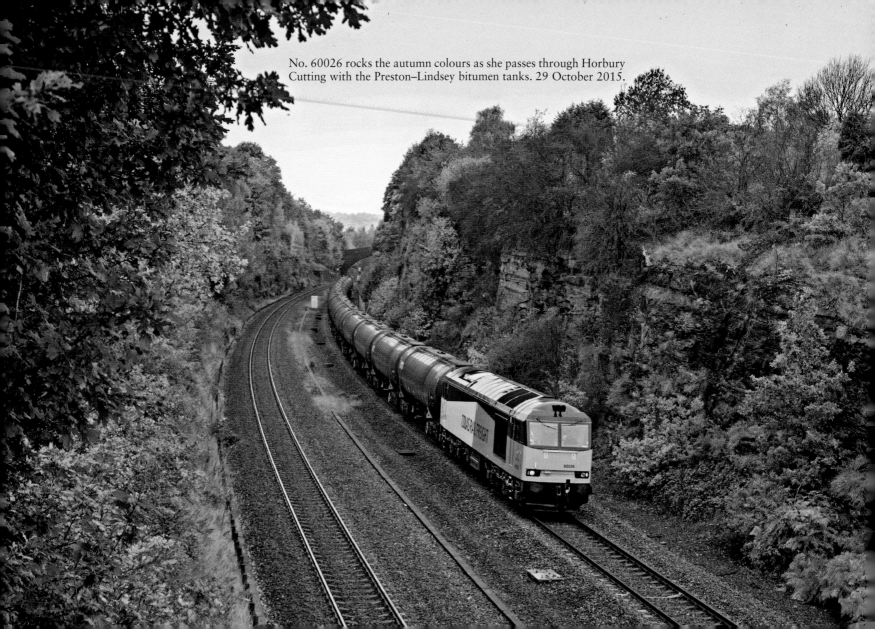

No. 60026 rocks the autumn colours as she passes through Horbury Cutting with the Preston–Lindsey bitumen tanks. 29 October 2015.

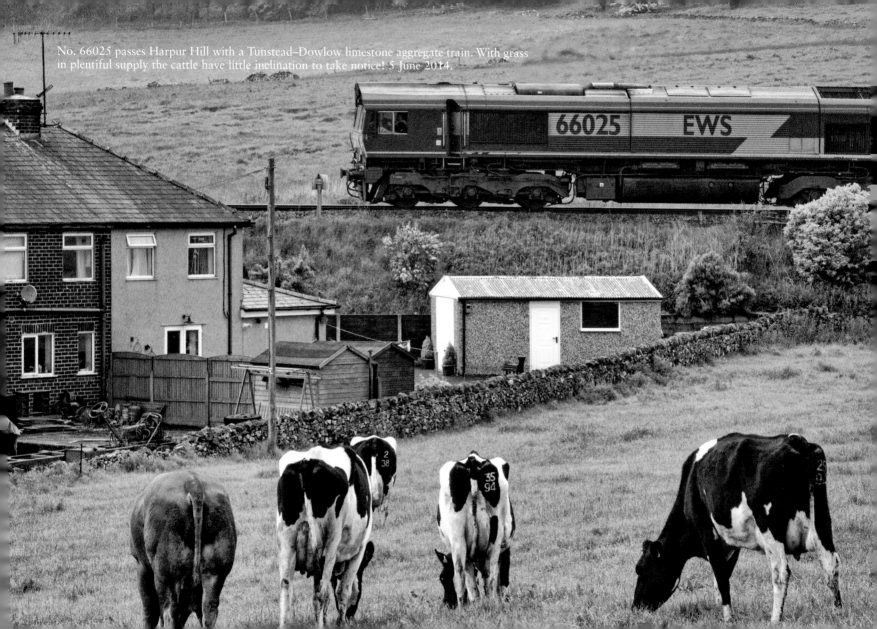

No. 66025 passes Harpur Hill with a Tunstead–Dowlow limestone aggregate train. With grass in plentiful supply the cattle have little inclination to take notice! 5 June 2014.

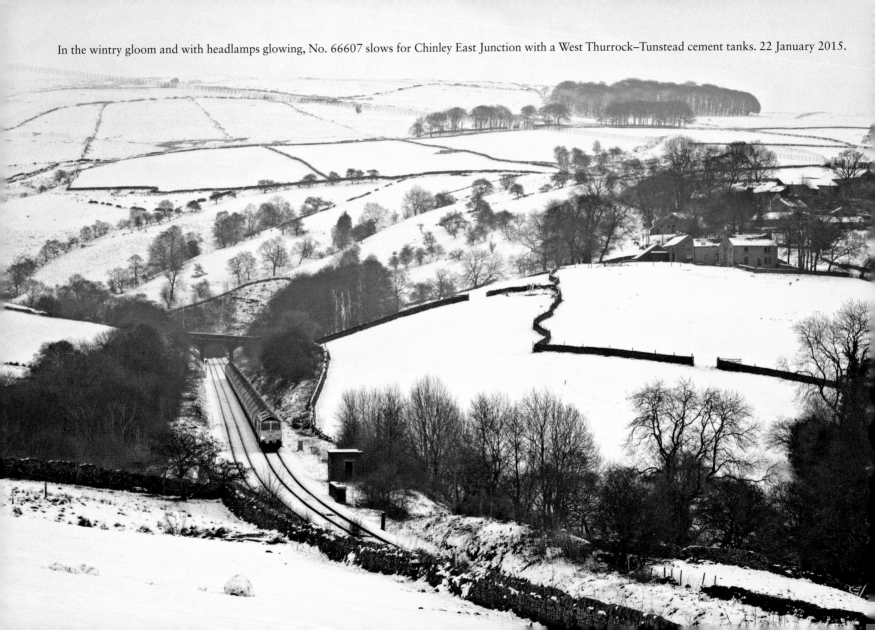

In the wintry gloom and with headlamps glowing, No. 66607 slows for Chinley East Junction with a West Thurrock–Tunstead cement tanks. 22 January 2015.

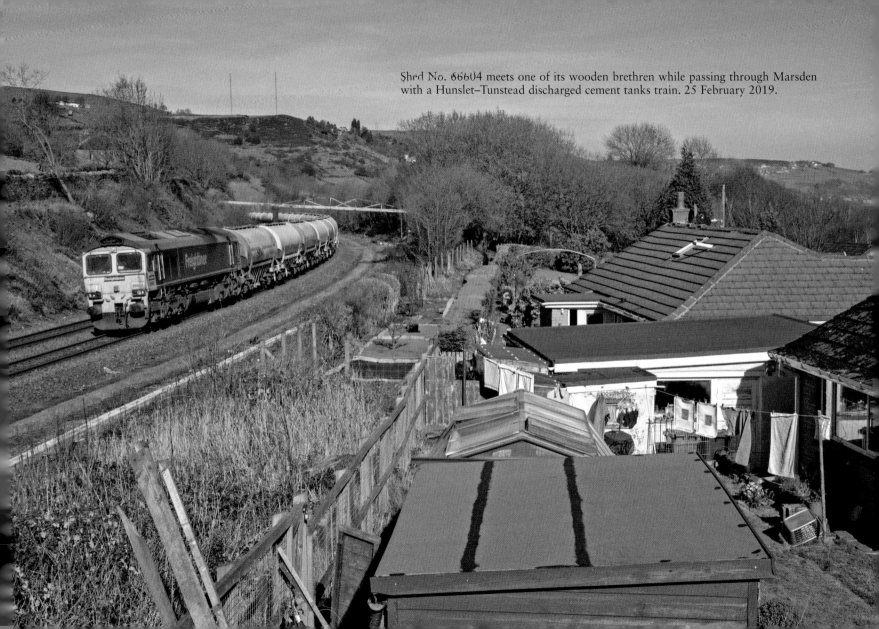

Shed No. 66604 meets one of its wooden brethren while passing through Marsden with a Hunslet–Tunstead discharged cement tanks train. 25 February 2019.

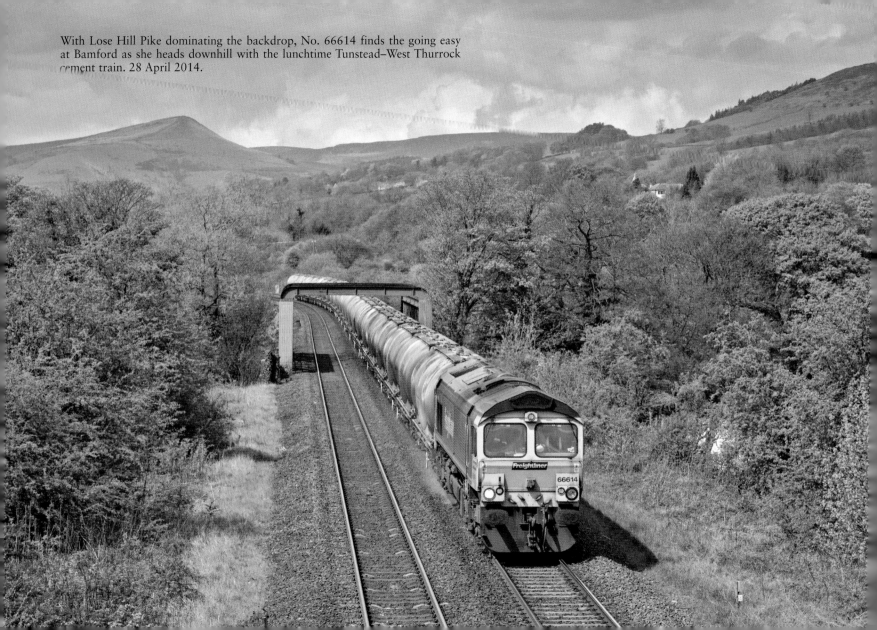

With Lose Hill Pike dominating the backdrop, No. 66614 finds the going easy at Bamford as she heads downhill with the lunchtime Tunstead–West Thurrock cement train. 28 April 2014.

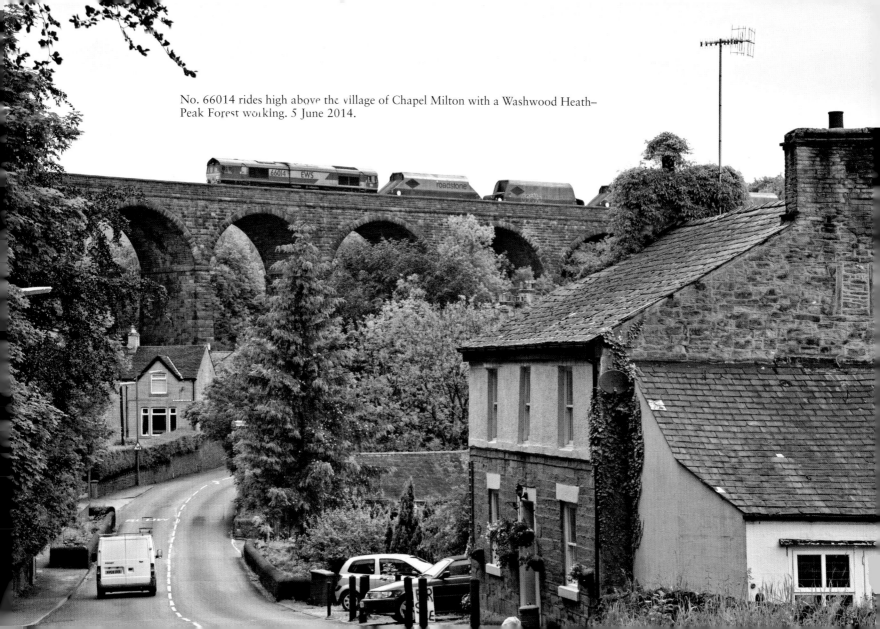

No. 66014 rides high above the village of Chapel Milton with a Washwood Heath–Peak Forest working. 5 June 2014.

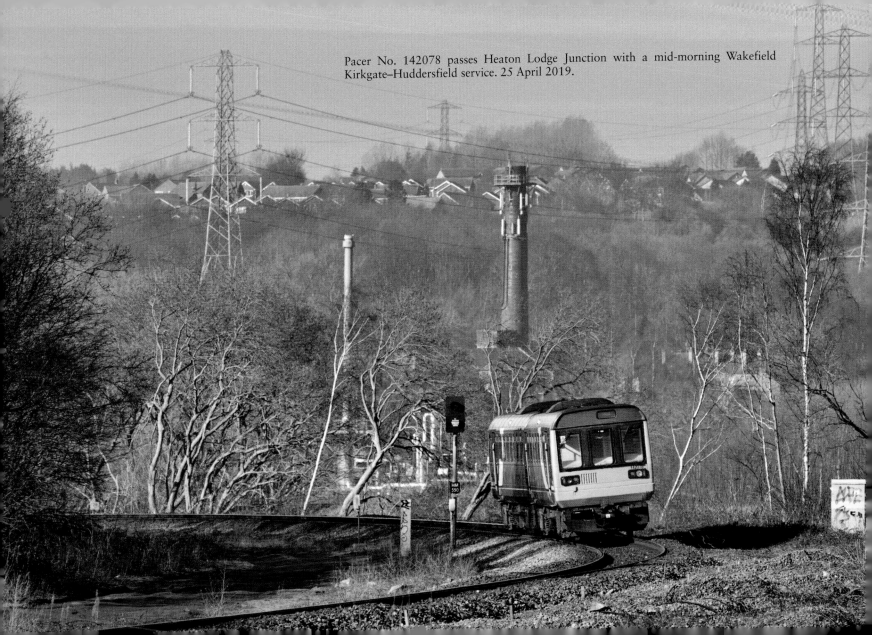

Pacer No. 142078 passes Heaton Lodge Junction with a mid-morning Wakefield Kirkgate–Huddersfield service. 25 April 2019.

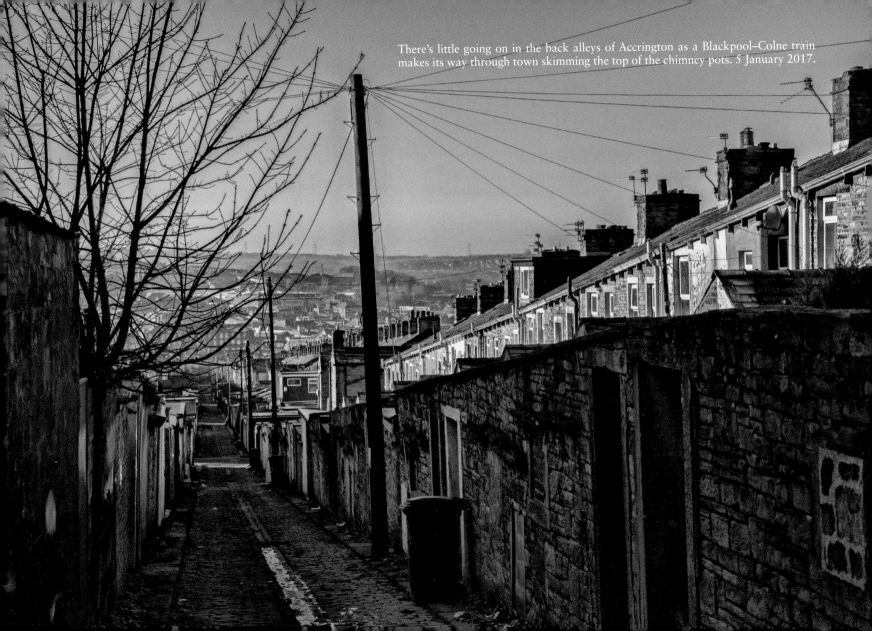

There's little going on in the back alleys of Accrington as a Blackpool–Colne train makes its way through town skimming the top of the chimney pots. 5 January 2017.

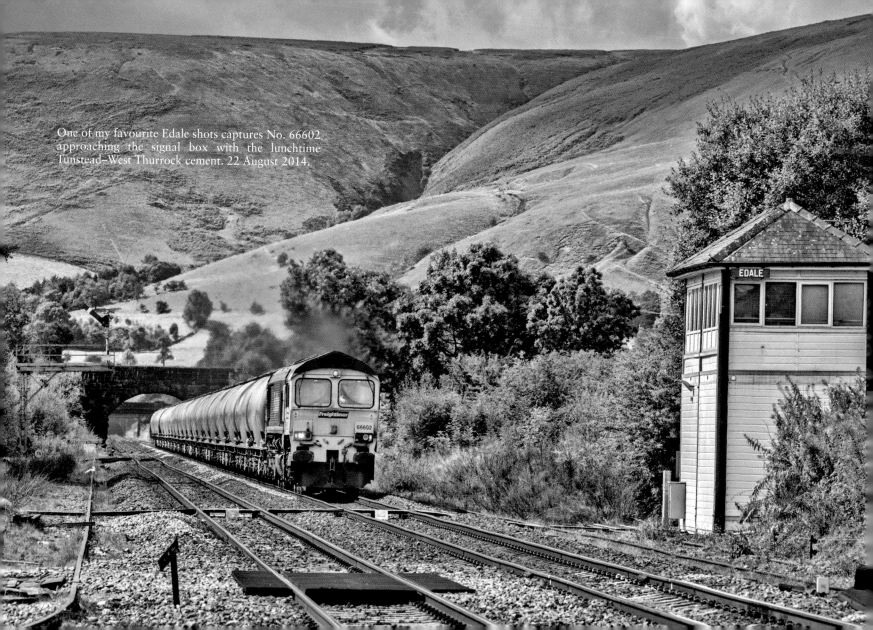

One of my favourite Edale shots captures No. 66602 approaching the signal box with the lunchtime Tunstead–West Thurrock cement. 22 August 2014.

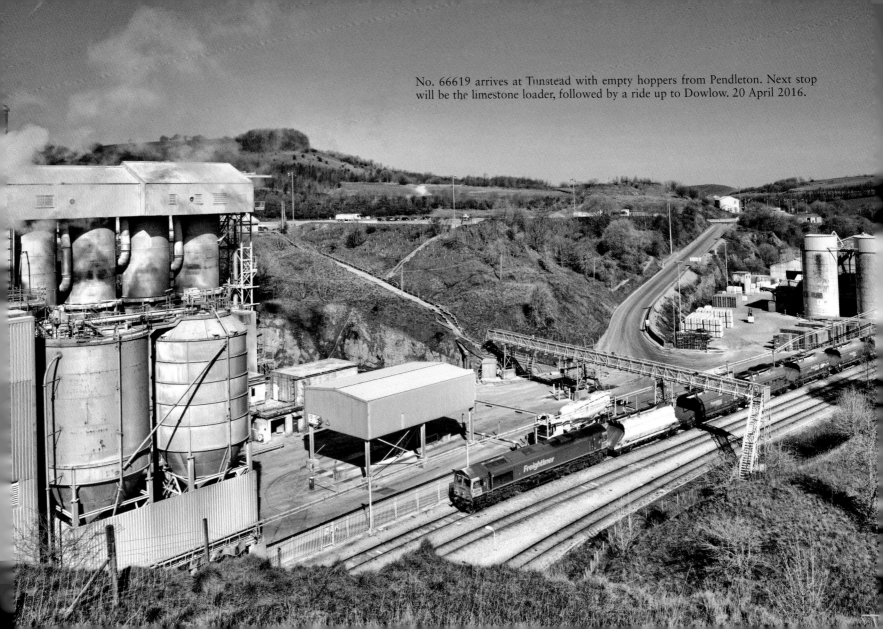

No. 66619 arrives at Tunstead with empty hoppers from Pendleton. Next stop will be the limestone loader, followed by a ride up to Dowlow. 20 April 2016.

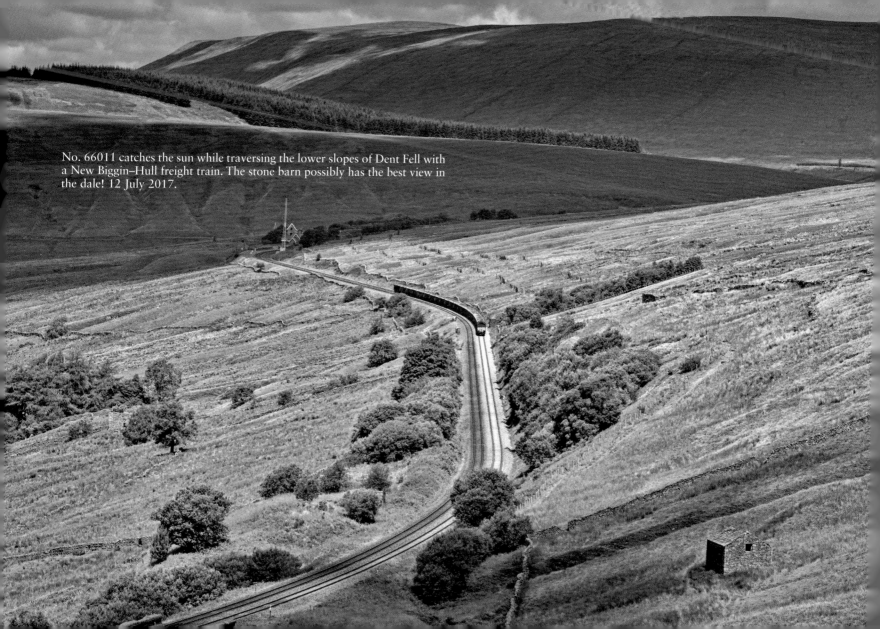

No. 66011 catches the sun while traversing the lower slopes of Dent Fell with a New Biggin–Hull freight train. The stone barn possibly has the best view in the dale! 12 July 2017.

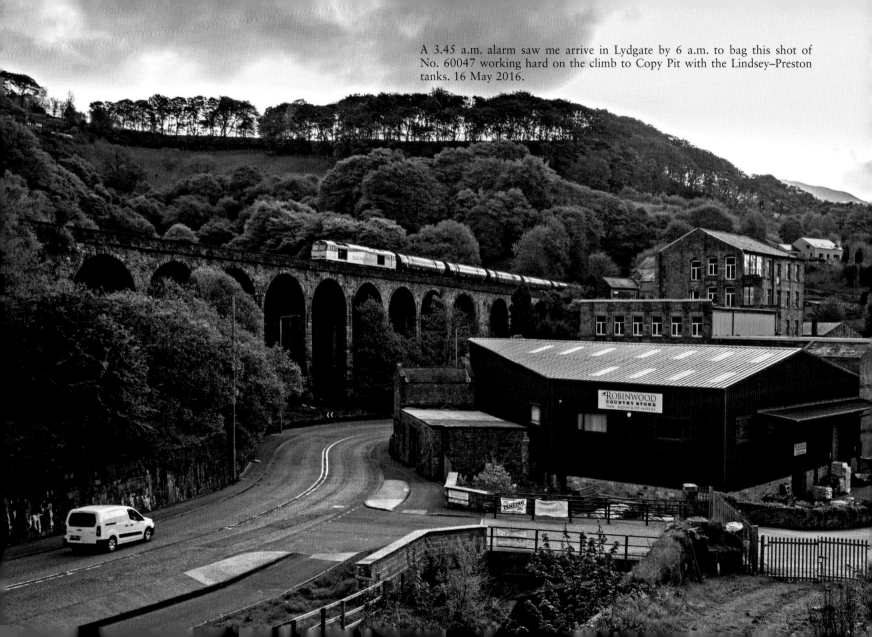

A 3.45 a.m. alarm saw me arrive in Lydgate by 6 a.m. to bag this shot of No. 60047 working hard on the climb to Copy Pit with the Lindsey–Preston tanks. 16 May 2016.

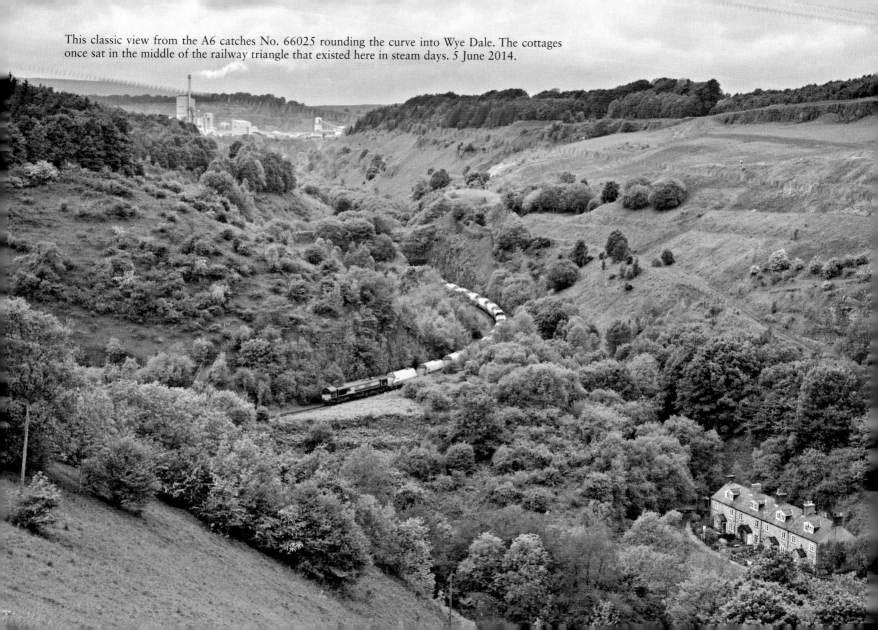

This classic view from the A6 catches No. 66025 rounding the curve into Wye Dale. The cottages once sat in the middle of the railway triangle that existed here in steam days. 5 June 2014.

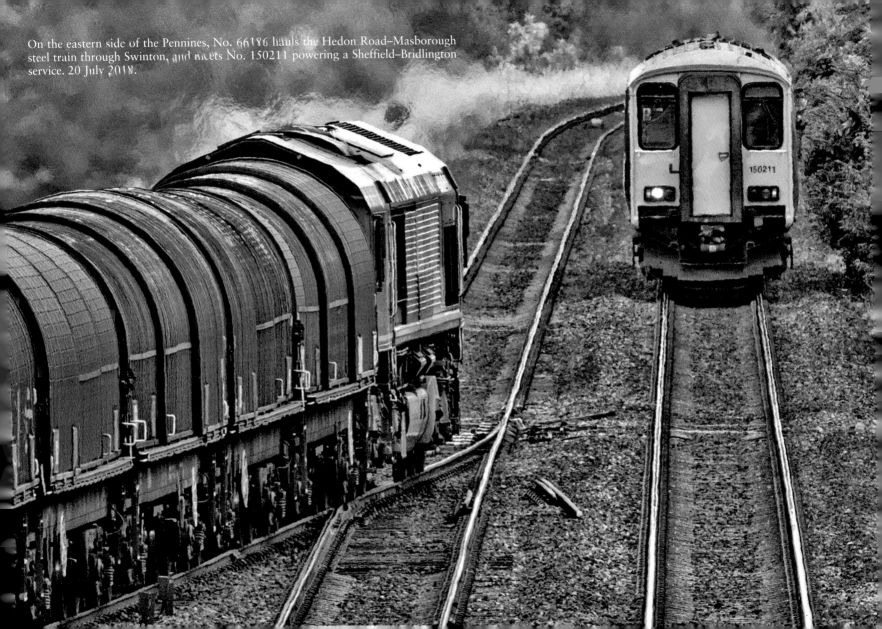

On the eastern side of the Pennines, No. 66186 hauls the Hedon Road–Masborough steel train through Swinton, and meets No. 150211 powering a Sheffield–Bridlington service. 20 July 2018.

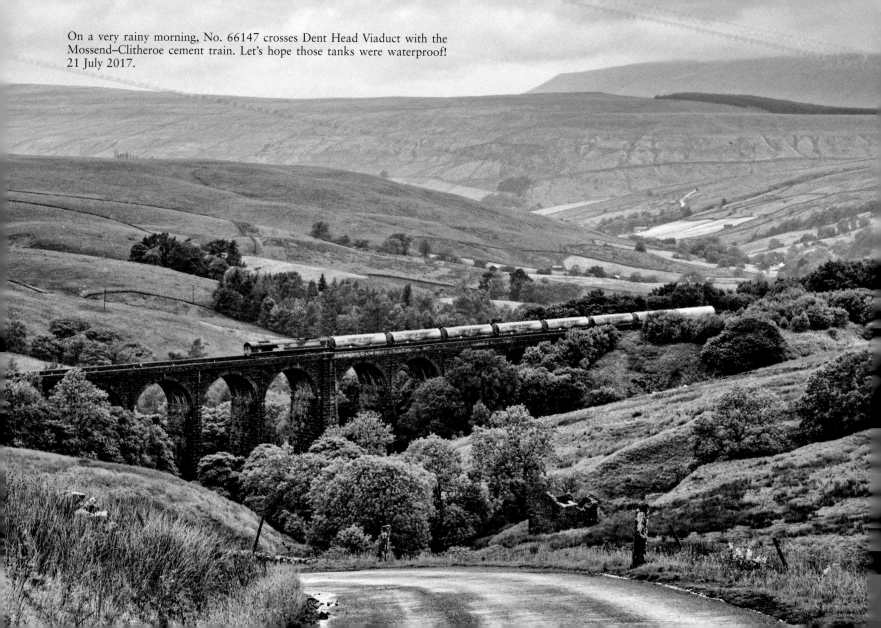

On a very rainy morning, No. 66147 crosses Dent Head Viaduct with the Mossend–Clitheroe cement train. Let's hope those tanks were waterproof! 21 July 2017.

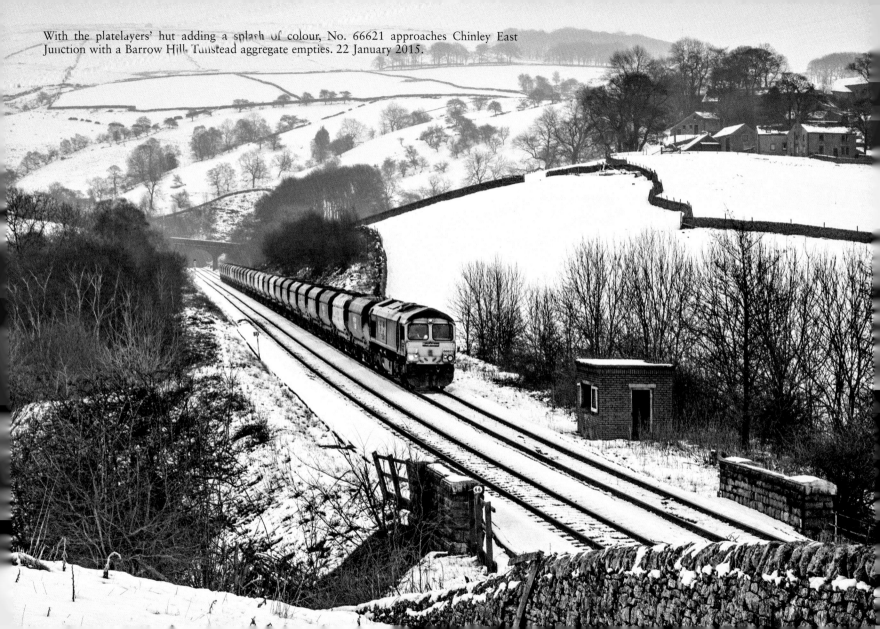

With the platelayers' hut adding a splash of colour, No. 66621 approaches Chinley East Junction with a Barrow Hill-Tunstead aggregate empties. 22 January 2015.

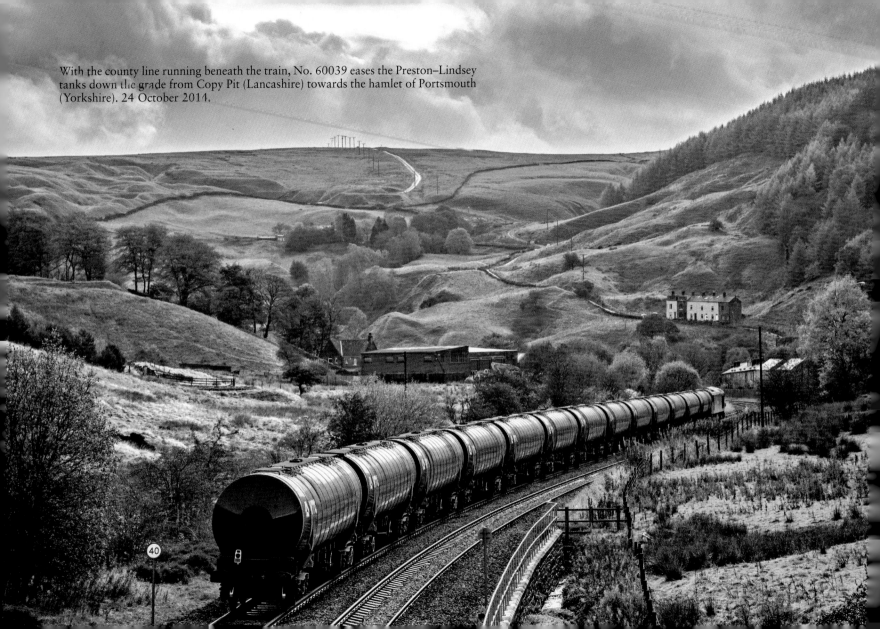

With the county line running beneath the train, No. 60039 eases the Preston–Lindsey tanks down the grade from Copy Pit (Lancashire) towards the hamlet of Portsmouth (Yorkshire). 24 October 2014.

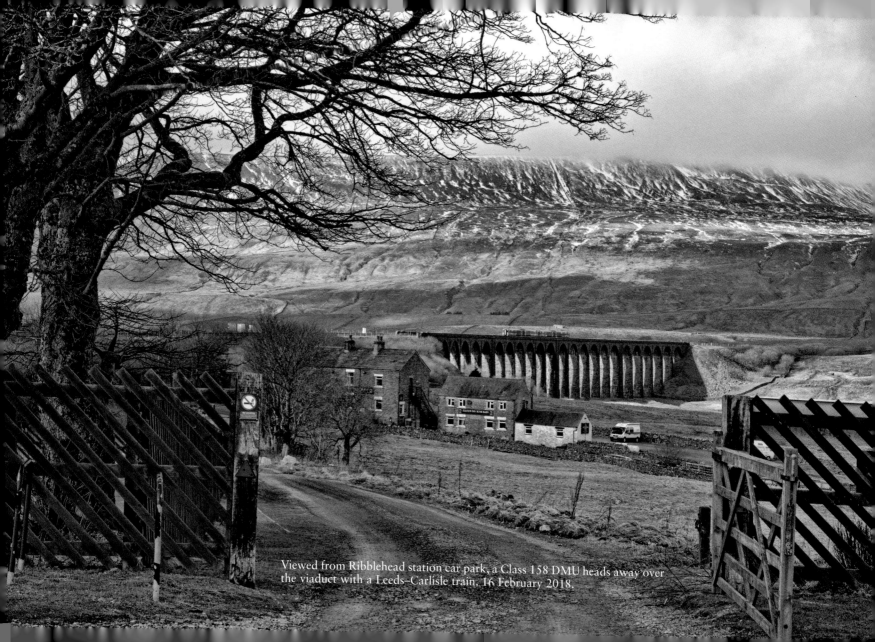

Viewed from Ribblehead station car park, a Class 158 DMU heads away over the viaduct with a Leeds–Carlisle train, 16 February 2018.

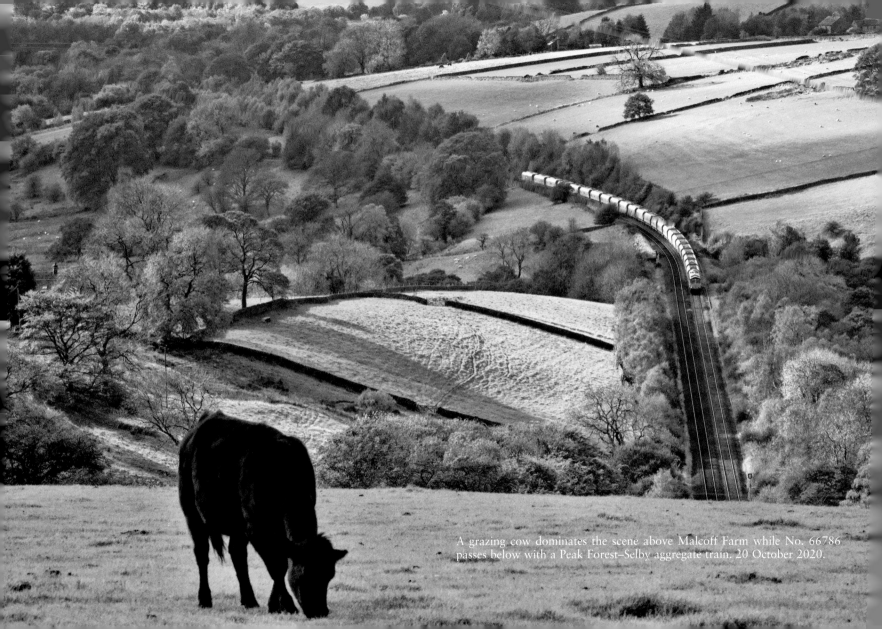

A grazing cow dominates the scene above Malcoff Farm while No. 66786 passes below with a Peak Forest–Selby aggregate train. 20 October 2020.

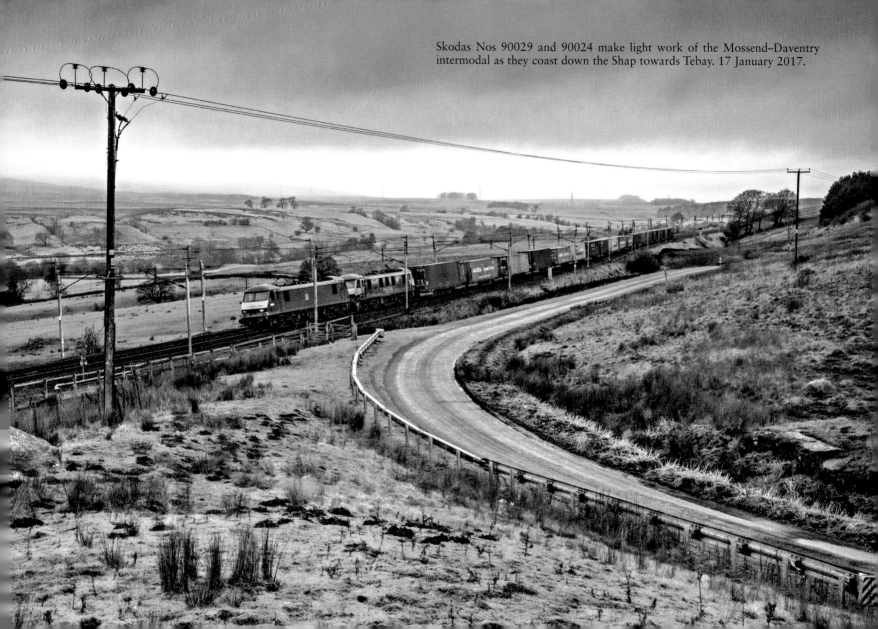

Skodas Nos 90029 and 90024 make light work of the Mossend–Daventry intermodal as they coast down the Shap towards Tebay. 17 January 2017.

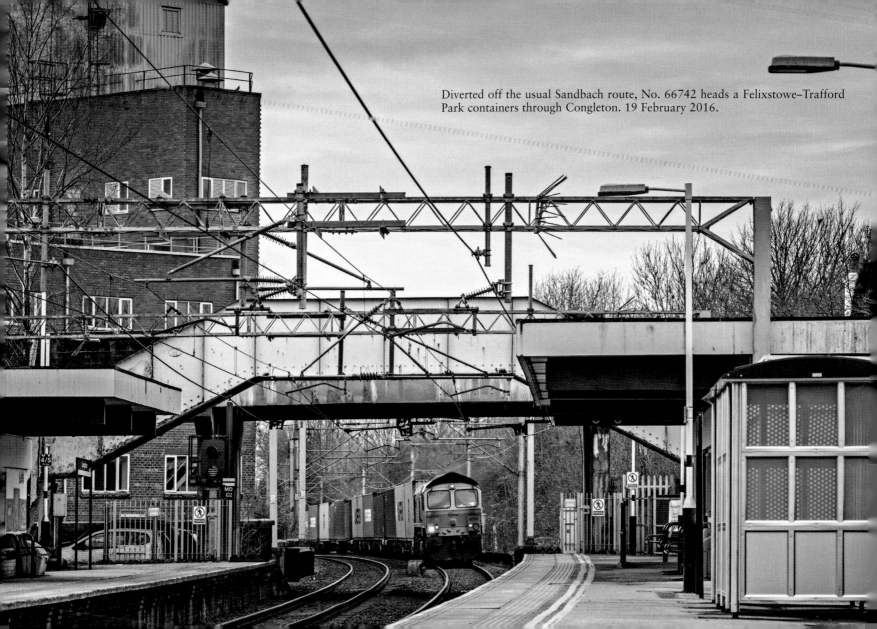

Diverted off the usual Sandbach route, No. 66742 heads a Felixstowe–Trafford Park containers through Congleton. 19 February 2016.

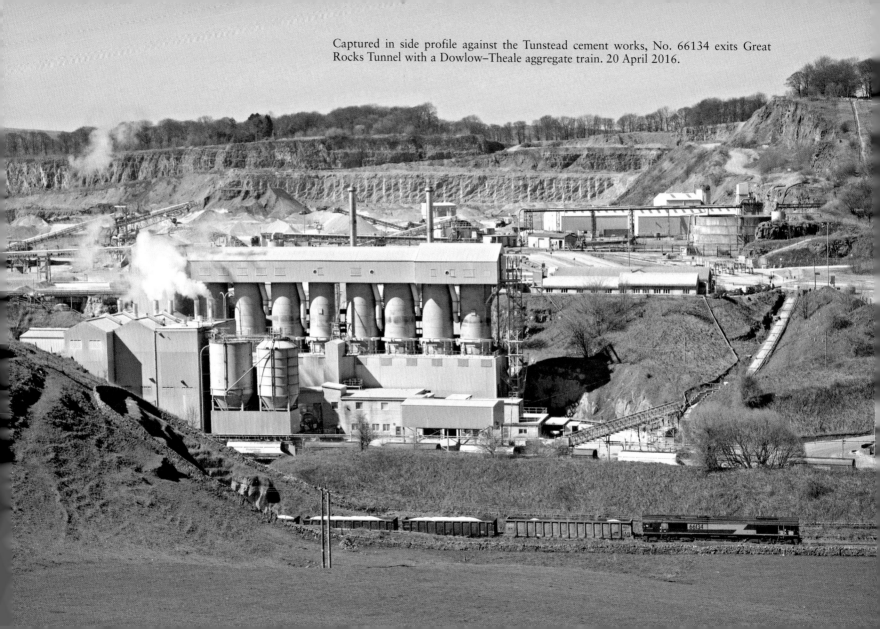

Captured in side profile against the Tunstead cement works, No. 66134 exits Great Rocks Tunnel with a Dowlow–Theale aggregate train. 20 April 2016.

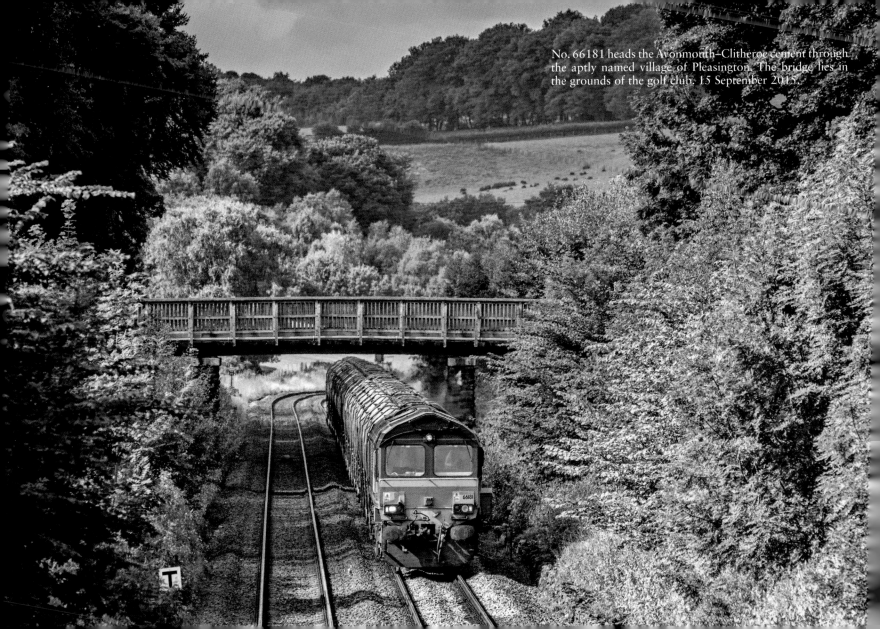

No. 66181 heads the Avonmouth–Clitheroe cement through the aptly named village of Pleasington. The bridge lies in the grounds of the golf club. 15 September 2015.

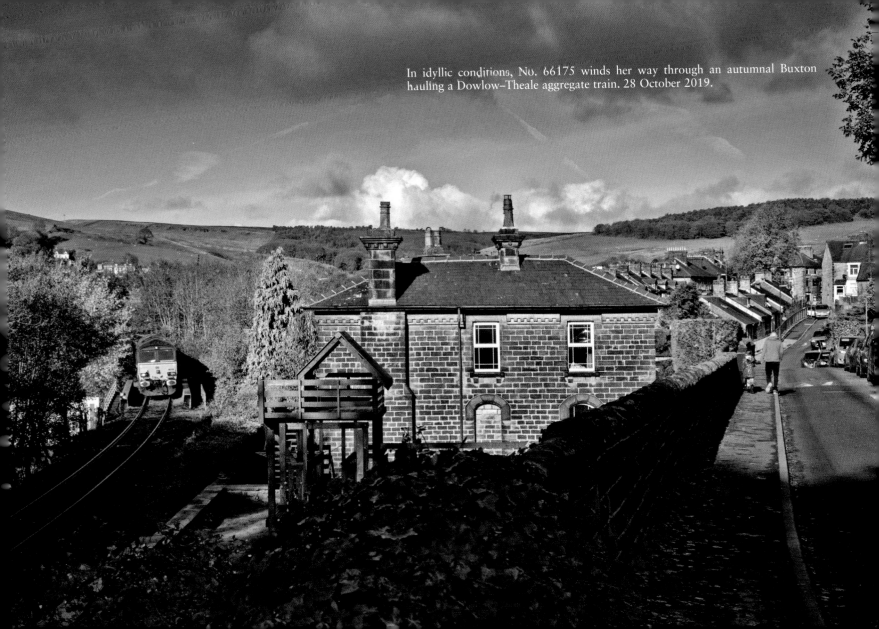

In idyllic conditions, No. 66175 winds her way through an autumnal Buxton hauling a Dowlow–Theale aggregate train. 28 October 2019.

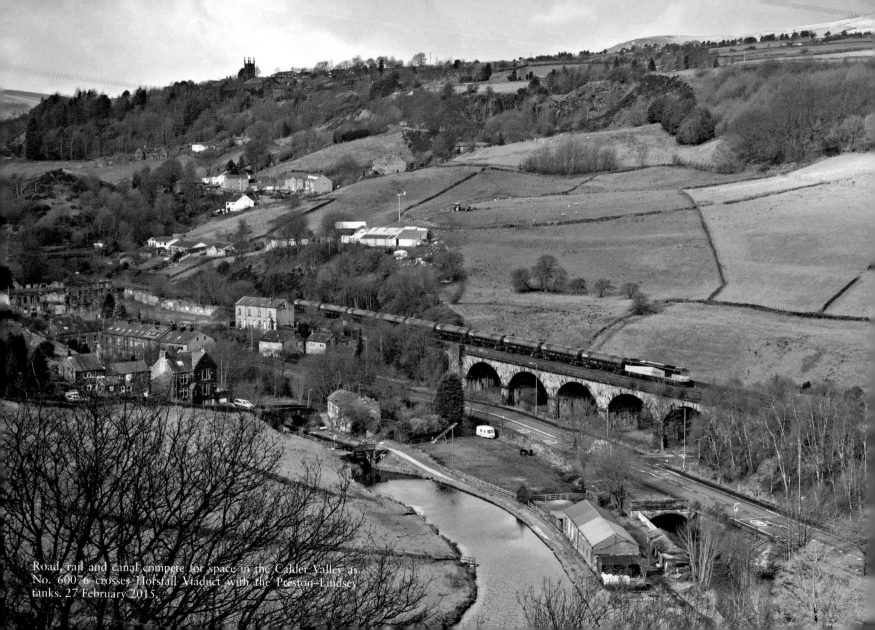

Road, rail and canal compete for space in the Calder Valley as No. 60076 crosses Horsfall Viaduct with the Preston-Lindsey tanks. 27 February 2015

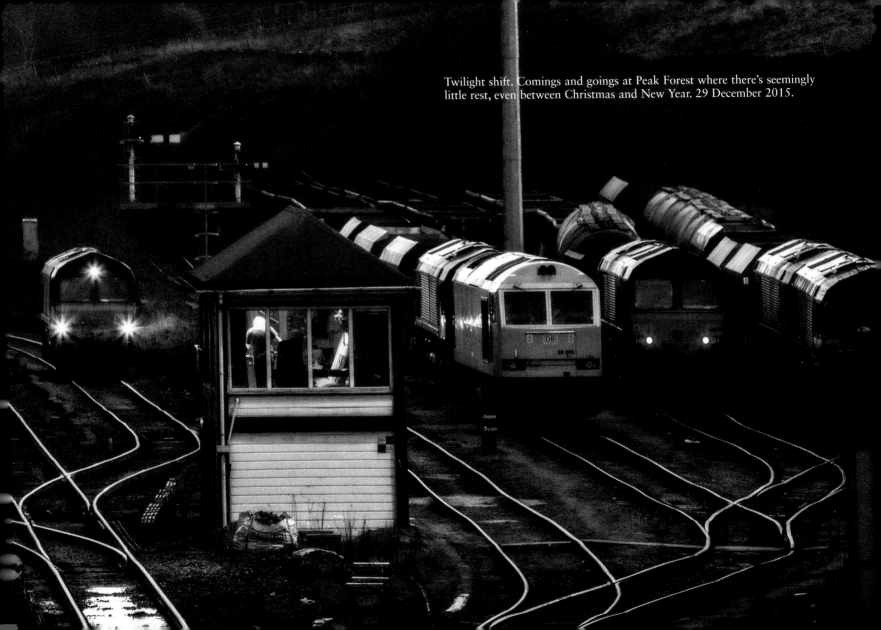

Twilight shift. Comings and goings at Peak Forest where there's seemingly little rest, even between Christmas and New Year. 29 December 2015.

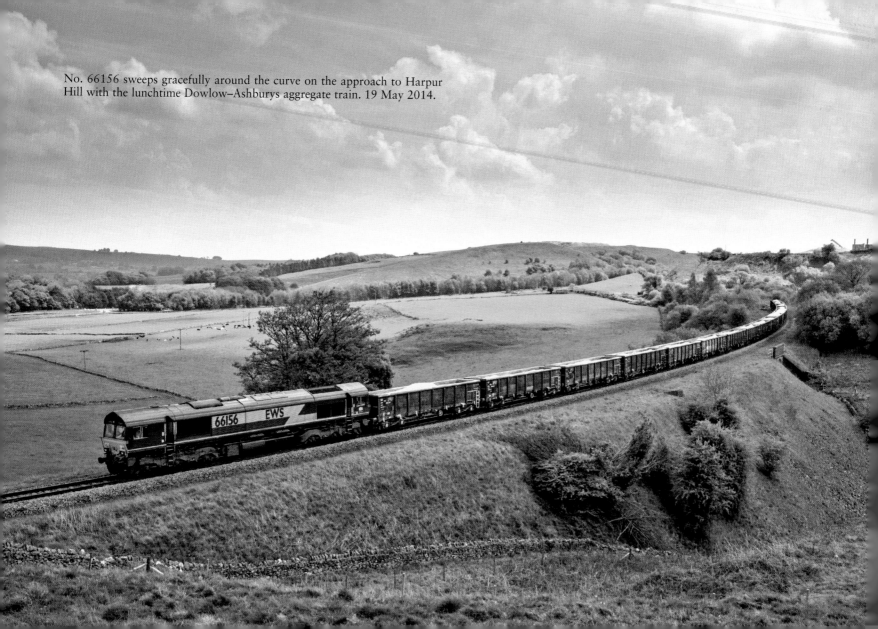

No. 66156 sweeps gracefully around the curve on the approach to Harpur Hill with the lunchtime Dowlow–Ashburys aggregate train. 19 May 2014.

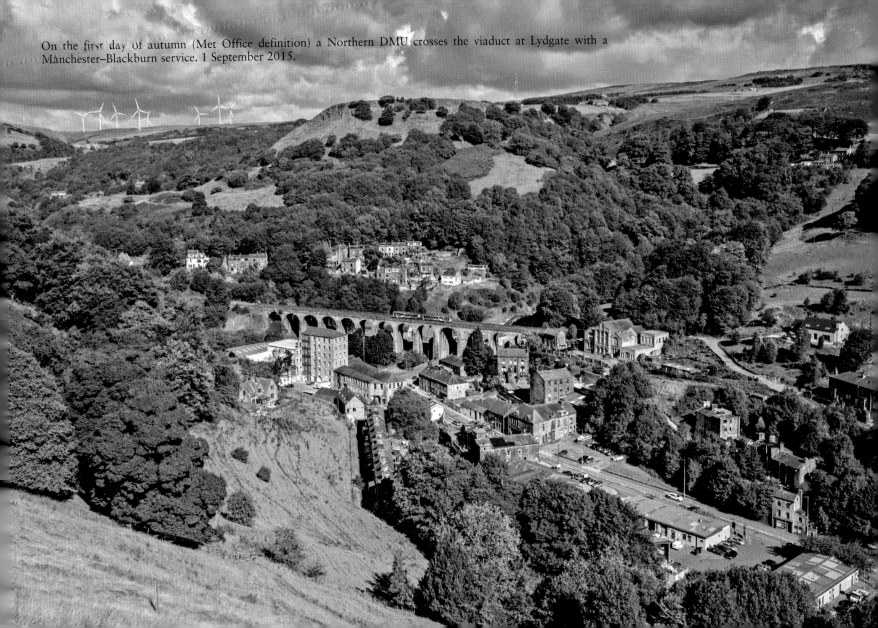

On the first day of autumn (Met Office definition) a Northern DMU crosses the viaduct at Lydgate with a Manchester–Blackburn service. 1 September 2015.

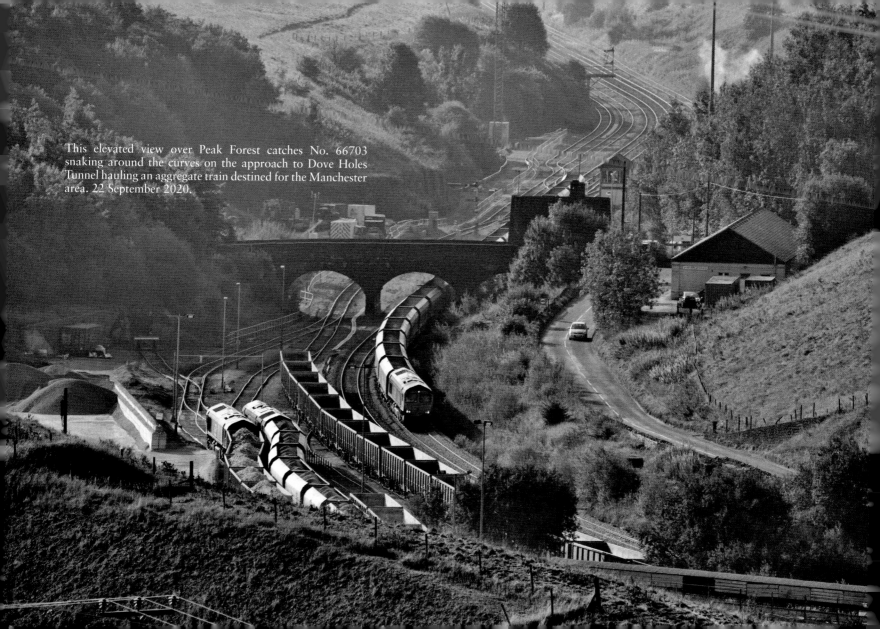

This elevated view over Peak Forest catches No. 66703 snaking around the curves on the approach to Dove Holes Tunnel hauling an aggregate train destined for the Manchester area. 22 September 2020.

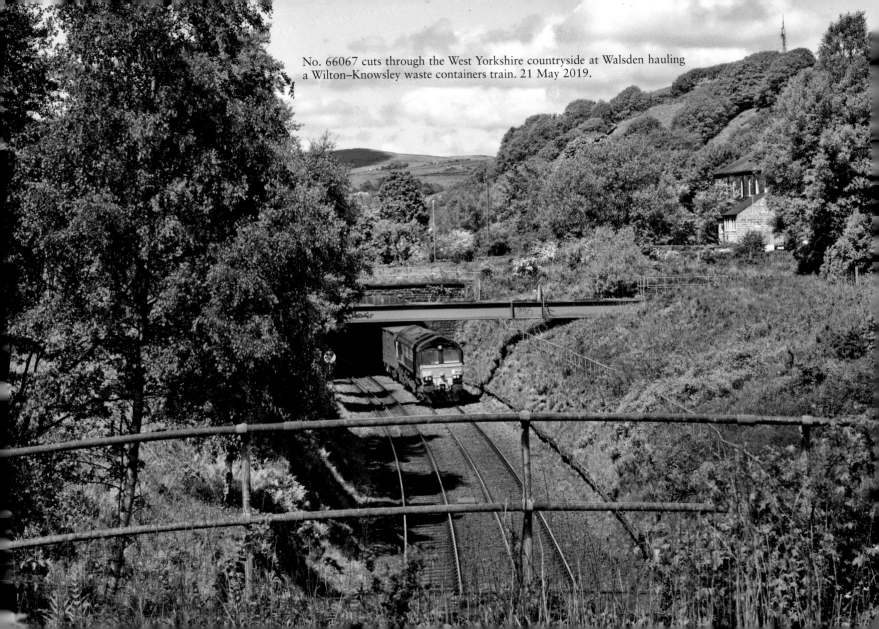

No. 66067 cuts through the West Yorkshire countryside at Walsden hauling a Wilton–Knowsley waste containers train. 21 May 2019.

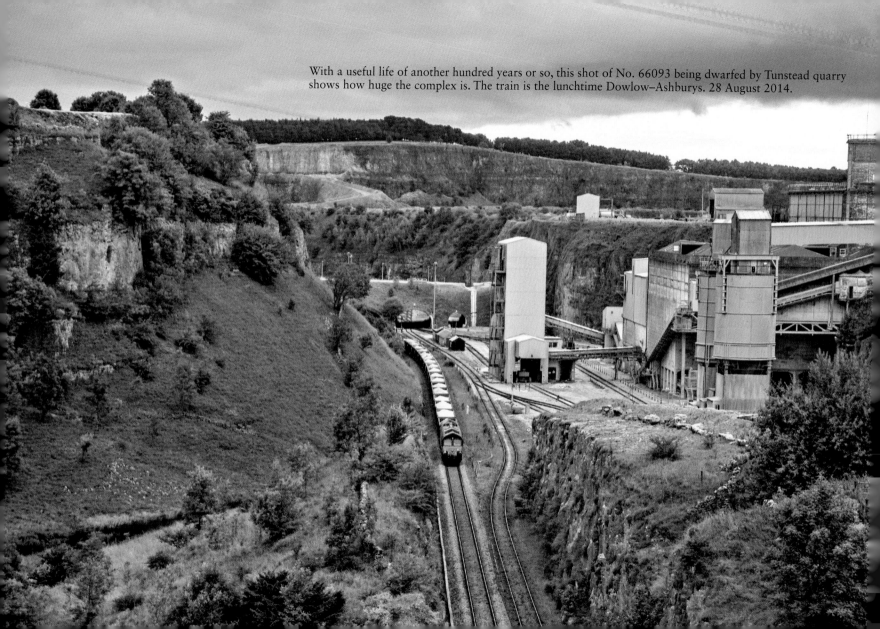

With a useful life of another hundred years or so, this shot of No. 66093 being dwarfed by Tunstead quarry shows how huge the complex is. The train is the lunchtime Dowlow–Ashburys. 28 August 2014.

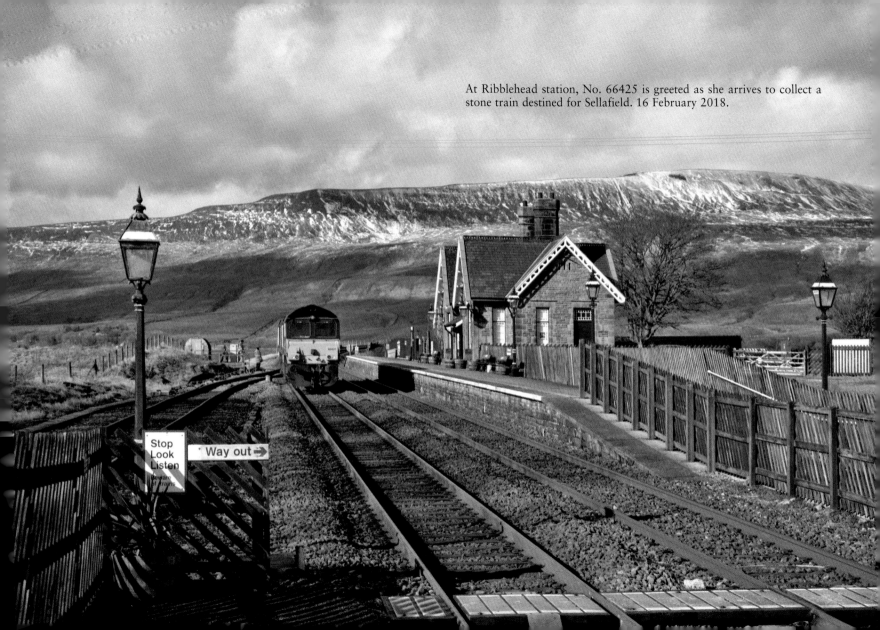

At Ribblehead station, No. 66425 is greeted as she arrives to collect a stone train destined for Sellafield. 16 February 2018.

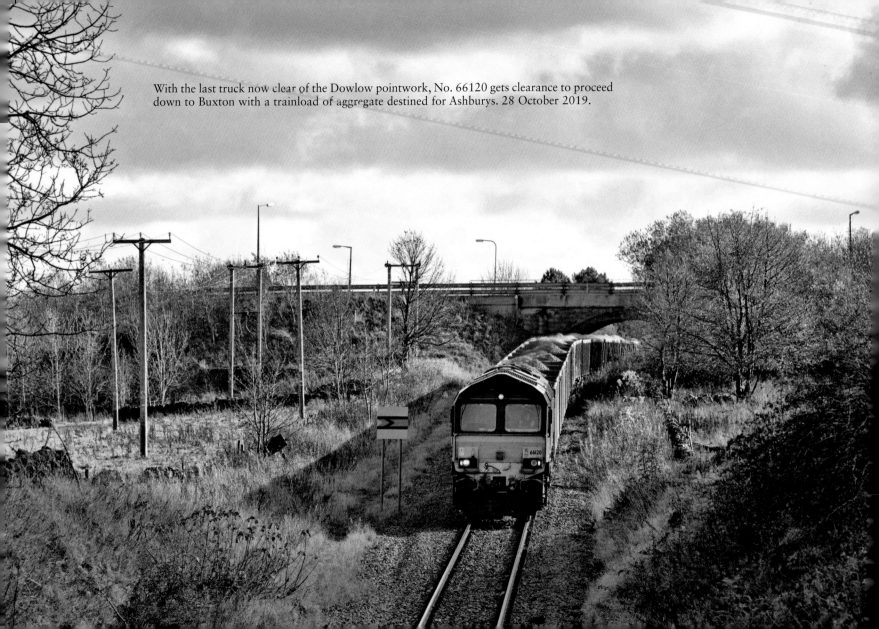

With the last truck now clear of the Dowlow pointwork, No. 66120 gets clearance to proceed down to Buxton with a trainload of aggregate destined for Ashburys. 28 October 2019.

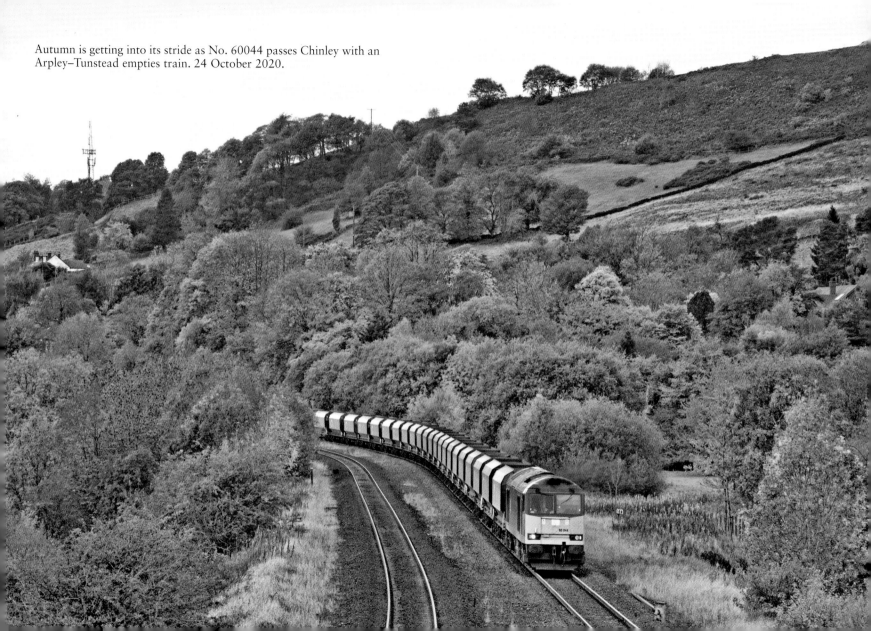

Autumn is getting into its stride as No. 60044 passes Chinley with an Arpley–Tunstead empties train. 24 October 2020.

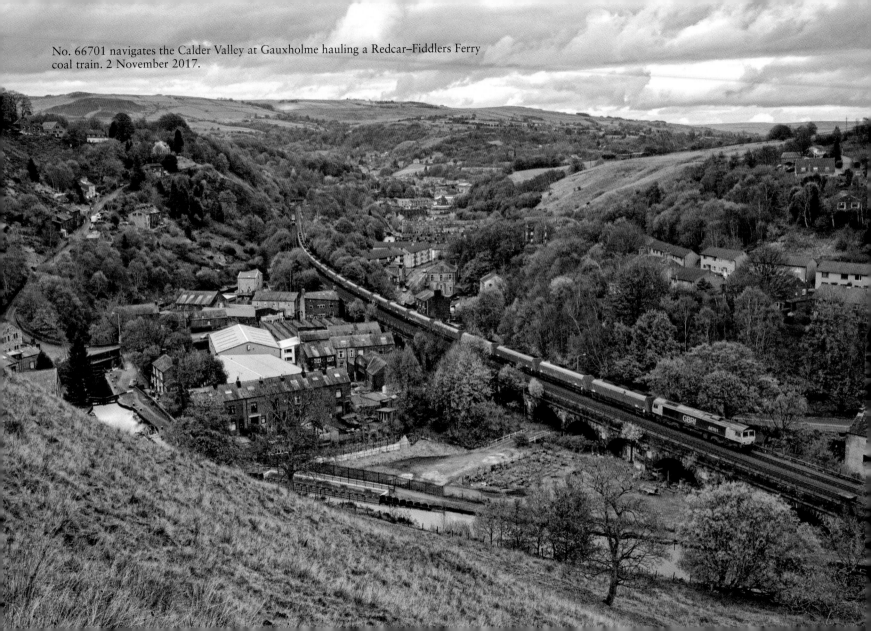

No. 66701 navigates the Calder Valley at Gauxholme hauling a Redcar–Fiddlers Ferry coal train. 2 November 2017.